Birdie:

THE GIRL NEXT DOOR

BY

Birdie Lee JONES

TATE PUBLISHING, LLC

Published in the United States of America
by Tate Publishing, LLC
127 East Trade Center Terrace
Mustang, OK 73064
(888) 361–9473

ISBN: 1-5988602-6-7

 *D*edication

This book is dedicated to God.

Thank you God for the inspiration you have given me to write this book. It demonstrates to every reader your power, love and desires to fulfill your purpose in the lives of your people.

Acknowledgements &
Special Thanks

To my mother, Beatrice Ikner, who allows God to use her through visions as a messenger of grace and favor. You taught and demonstrated to me the necessity and power of prayer. Your prayers are constantly with me.

To my late father, Willie M. Johnson, who gave me the name "Birdie" which I proudly display as the title of this book.

To my husband, Rev. E. J. Jones, MD, "the boy next door" who responded so often when I was unable to complete the work by becoming more than a help mate. This book could not have been developed without you.

To my former pastors, the late Rev. Dr. B. H. Roberts, Rev. C. E. McClain, Dr. Donald Ray McNeil, Apostle Dorothy Washington, Bishop Shelton Bady and all of my instructors at Houston Graduate School of Theology. All have helped me to become like who I look to the most.

Tyler Perry—thank you! Watching an interview of you on your DVD of "I Can Do Bad All by

Myself" inspired me to keep my focus. My writing is simple and the message is powerful. I pray each reader will take the message for what it is worth.

To my family—Linda and Helen (deceased), my sisters; L'lana, Janice and Breiana, my nieces; Elizabeth, my granddaughter; Zanetta, my daughter; Wilbert, my nephew; Dana, my son-in-law and Leo, (daddy). You caused my days to have greater joy and meaning. Thank you for your support.

To God's Way Community Church members for covering me with prayers and encouragement when I needed it most. To all my friends who have loved and supported me with words of wisdom.

To Tate Publishing & Enterprises for having faith in my book and helping to make crooked places straight

Foreword

Some individuals do not like to relate stories about their ups and downs in their lives. They are afraid or embarrassed about their situations in life. We all have trials and tribulations and go through the Valley of the Shadow of Death from time to time. Here is an individual who has had ups and downs in her life. She did not ask God to remove the hard times. She only wanted Him to give her strength to climb the mountains in her life. She is willing to tell her story and pray that it will be an inspiration to others. Her faith in God has steadied her through trials and tribulations, through good times and bad times.

As you read about her, continue in prayer with her. God has used her for His good and may He continue to do so. Daily as she travels along life's highway, she yields to His presence.

She is a sweet and lovable person. I see her on a daily basis. I knew her as the girl next door and I know her even more closely for I am married to "Birdie—The Girl Next Door".

Rev. Ernest J. Jones, MD

Chapter One

EARLY on Sunday morning (4:45 A.M.) December 29, 1946 I was born during an unbelievable cold, bone chilling snowstorm to Willie and Beatrice Johnson in the Old Jefferson Davis Hospital located on the Westside of near downtown Houston, Texas. But despite the weather, my parents were celebrating the birth of their first child together.

My mother has always enjoyed telling us how happy she was that I was not born on Christmas Day, because she really wanted to eat the Christmas meal she had prepared. So often I have been asked, "How did you get the name Birdie?" or, "Is Birdie your real name?"

According to my mother, during the Thanksgiving meal just before my birth, my father announced to his family that he only had one sister and when the baby was born if it was a girl she would be named after her, "Birdie". Needless to say, mama's mouth fell open. You see, she had already selected the name

"Diane" which was very popular during that time. Yes, I was going to be one of thousands with that name. But Willie Johnson changed that. My Aunt Birdie, her daughter, Glynell and my father's mother Bessie Barrard were very happy. Mama said on the way home she told Daddy she did not want that old name for her baby child. She had already selected my name—well, it was too late for changes. My Aunt Birdie, who I came to know as "Ninnie" always referred to me as her namesake. For a long time I did not like my name but before Ninnie died her two grandsons, Elliotte and Canard, called her "Mama Birdie".

As years have passed I came to accept my name with gratitude and lots of sweet memories. I had even hoped my great niece; Breiana would call me Mama Birdie. However, like her mother, L'lana, she calls me "Auntie".

A GOOD NAME IS MORE DESIRABLE THAN GREAT RICHES; TO BE ESTEEMED IS BETTER THAN SILVER OR GOLD (PROVERBS 22:1).

My mother had one child from her first marriage, Helen Joyce. She was seven years older than me. Everybody called her "Poky". For seven years she was my closest playmate. Seven years after I was born, Mama gave birth to another girl, Linda Faye. No problems were involved with her name. Mama would always say "I have three girls seven years apart; when one entered school another was left behind."

I often refer to myself as an old man's child. Daddy was twenty years older than Mama. He had been married before and had a son from that marriage. His name was Willie (we called him Boo-Boo). He was born the same month and year as my mother. Boo-Boo was perhaps the only brother a girl could have who never punched his little sister or caused her deep distress. He was old enough to be my father. Boo-Boo had one child, Margaret, a very pretty bright eyed curly haired girl whom I enjoyed playing with two weeks out of every summer. I can recall how my father's mother never wanted us to leave the yard to play with other friends and cousins on East 32nd Street. Texas is a very hot state during the summer months, especially Houston. My grandmother (Bessie) would put us in the back yard to play having only our white eyelet panties on. She believed in keeping her family at home. We were precious pearls in her eyesight, to be guarded from negative things and people in the world. We often had to plead with Ninnie (Aunt Birdie) to tell mama to let us visit. Two hours was the maximum amount of time that was allowed to visit, if that long. Our summer vacation away from home also included visiting my other grandmother (Nannie). Everyday you had to take a nap before receiving ice cream treats. Most of our time was spent at home laughing and talking with Nannie and Uncle Frank, her husband. Nannie was also a member of the Herald of Jericho. The Herald of Jericho is an organization in line with the Eastern Stars/Masons. During one of our visits, Helen, Linda

and I attended a Lodge meeting enjoying cookies and punch. During this meeting Linda was trying to find out what the secret pass word was. Nannie never told her the word and Linda never stopped asking. Although we loved our grandparents we loved being in our own back yard.

My story begins with some very early events which lead to the beginning of a love story. It is a most unusual story because it started forty-six years ago. Once I begin to tell it to most people it brings on tears and they are amazed and say it sounds like a fairy tale. In so many ways it *is* like a fairy tale. Of course, I have to admit in all of it I see the real truth, and that is that God keeps His promises. I want to begin by including a passage from the Word of God and I will do this throughout the story. I feel the Scripture will have to lead me for I have faith in the Word of God.

I WILL STAND AT MY WATCH AND STATION MYSELF ON THE RAMPARTS; I WILL LOOK TO SEE WHAT HE WILL SAY TO ME, AND WHAT ANSWER I AM TO GIVE TO THIS COMPLAINT. THEN THE LORD REPLIED: WRITE DOWN THE REVELATION AND MAKE IT PLAIN ON TABLETS SO THAT A HERALD MAY RUN WITH IT. FOR THE REVELATION WAITS AN APPOINTED TIME; IT SPEAKS OF THE END AND WILL NOT PROVE FALSE. THOUGH IT LINGER, WAIT FOR IT; IT WILL CERTAINLY COME AND WILL NOT DELAY. SEE, HE IS PUFFED UP; HIS DESIRES ARE NOT UPRIGHT—BUT THE RIGHTEOUS WILL LIVE BY HIS FAITH (HABAKKUK 2:1-4).

At the age of three, I remember being very sick. I was so sick that no one would play with me or my toys. Mama says I had a fever so high she and

daddy did not know what to do in order to break it. I was examined by a doctor who said I had what was known as "trench mouth disease" which I had probably contracted from soldiers returning home after World War II. With around the clock care from Mama and Daddy, I escaped what the doctor felt would have been definite death had he placed me in the hospital. As time passed, I grew stronger and continued toward a normal childhood life.

In our household there were a lot of problems. My mother and father had lots of disagreements. Our family had periods when there was lots of joy and there were periods of lots of sorrow. There were times when there was a lot of fighting and arguments and a lot of things that children listened to that perhaps they should not have to hear. But, I had a very happy childhood, and I guess in some ways, a traumatic childhood but there was order for me, because my mother and father required that I be obedient.

CHILDREN OBEY YOUR PARENTS IN THE LORD, FOR THIS IS RIGHT (EPHESIANS 6:1).

I can recall one evening mama had hamburgers for the family. We were sitting around the dinner table and Mama and Daddy were talking while she cooked. Daddy would put his feet upon the edge of the table and Mama would always fuss at him about leaning in his chair and smoking. But, on this particular night they were just laughing and talking while she prepared hamburgers. After Mama completed all of the cooking she brought the burgers out and we sat

at the table and started to eat and we kept talking and laughing. Mama went back into the kitchen and said, "My goodness where did all of this meat come from? I have a plateful of patties in here. Did I put the meat in your hamburgers?" We all laughed because we did not notice if we had meat inside our burgers or not. We still laugh about that today. That was such a fun time.

Another time I recall Mama and Daddy lying across the bed. They were just talking and watching what was going on across the street. They had noticed a man coming from my Aunt Lillie's house. Aunt Lillie was my grandmother's sister. She and my mother grew up in the same house. Aunt Lillie was somewhat tall—about five feet seven inches tall. She had been out the night before and she was in no mood for early visitation. This salesman was trying to collect money. During that time, salesmen would go from house to house selling items on credit. Aunt Lillie had bought an ironing board and I guess she did not have the money to pay him or she did not desire to give him any money at that time. All of a sudden, Aunt Lillie went to the back of the house just fussing at the top of her voice, came back, opened her screen door wide and took the ironing board and threw it outside! She actually threw it at the man and closed her door. Mama and Daddy just started laughing. They thought they would never stop laughing because Aunt Lillie was just so funny.

Aunt Lillie was a person you just loved to be with. I spent a lot of time in her house. Actually,

she was the one who taught me to never leave home unless I had money enough in my pocket to get back home; regardless of who I was with. One day she gave me a little handkerchief and tied a quarter inside it and handed it to me. I was going to the movies with her children, Barbara Jean and Curtis. She always made me feel good. She was the one who encouraged us to try new things and to never stop learning. She would show us new games to play and how to be a successful individual. We lived in Fifth Ward, which the famous resident, Barbara Jordan called "Fifth Ward, Texas", it would often rain and there would be water everywhere. The ditches would be full of water and Aunt Lillie taught us to take a string and a little bacon and go out with our cans and catch crawfish. After having caught all the crawfish we could, we would bring them back. Aunt Lillie would say "Honey, you bring those crawfish back to me and I'm gonna cook 'em for you." She just enjoyed cooking for us and having lots of fun. I had a great time growing up in Fifth Ward. I played with Aunt Lillie's son Curtis and her daughter, Barbara Jean and my sister, Helen, most of the time.

I also had two little friends, Evelyn Bonton and Joyce Mae Wilson. We regularly played childhood games together. Joyce Mae was always the bossy one; more or less the leader of the group. One day while Mama was away, Joyce Mae encouraged me to go into the kitchen and began to try to bake a cake using what little staples Mama had. We had flour all over Mama's kitchen. When Mama returned,

she was very angry with us and fussed for hours. I
wished that she would have spanked us. Instead we
had to endure her verbal tongue-lashing.

Mama had a day for every thing. On Mondays
she washed. On Tuesday she would iron. Wednesday
was a very special day because Mama baked cakes
and pastries. We had an old ringer-type washing
machine and I was very interested in seeing it oper-
ate. I enjoyed going out in the back yard to watch
Mama hang up her washing. The sheets would come
out ever so white and so bright and I just enjoyed
running around and playing near Mama. She would
sing songs and talk to me as she worked.

Mama was home most of the day. Daddy
worked as a longshoreman. Ours was a very odd
situation. Mama was a Blues singer. She had a band,
"Bea and the Honey Bees", and to say the least, Mama
was a great singer. I have some wonderful newspaper
clippings about her and what different reporters and
critics thought about her singing. She even recorded
several records. Mama was really a cute person. I
remember Mama had a pair of green alligator shoes
and I loved those shoes so much that I begged Mama
to buy me a pair. I wanted green shoes like Mama.
I recall once we went shopping and Mama bought
alligator shoes for me. I loved them. I just thought
that was the best thing to ever happen to me because
I had shoes like Mama. Sometimes when Mama
and Daddy went out, I would go into her bedroom,
lift the window and sing songs as loud as I could to
the neighbors. I am sure they laughed and wished I

would stop. Neither Mama nor Daddy ever said that anyone complained about my singing.

My father always encouraged my Mama to sing. She said he was the one who motivated her and kept her going. He encouraged her and she enjoyed singing. However, while Mama was out singing and bringing in what little money she could; it allowed Daddy to stay home with us at night, and also gave him the opportunity to go out and do a lot of things perhaps he should not have done. He had too much time on his hands and found interests outside the family. He became involved with another woman and because of that involvement arguments continued in our household. Things were not as happy as they should have been for a very long time.

I can recall how Daddy used to get all dressed up on Friday nights. He would take a real good bath. He had a satin-looking shirt and I do not know what kind of cologne he wore, but you could smell him from the back door to the front door. I recall asking him, "Daddy, where are you going?" He would smile at me with those great big dimples and he would say, "Oh, I am going out to see my girlfriend," and he would start laughing. Daddy was a good looking man with big eyes and curly hair. Well, Daddy was really telling the truth, but he did it in such a way that I had no idea what he was actually doing. I think Daddy really thought he was a good-looking man. Women loved my Daddy and often chased him. They gave Mama a hard time. Daddy was a fun person to be around and could keep you laughing. He was very,

very sociable. I recall also that lots of musicians
came by to visit. I grew up around people who had
been in the world and they were fun. They were very
good to us.

My mother was one who shared everything
she had. I can remember Mama's kindness to one
family in particular. The husband played in the band
with Mama and they did not have any food to eat and
Mama had a pot of spaghetti left over in the refrig-
erator. She gave the whole pot to that family. I actu-
ally saw her give them the whole pot of food so they
could eat. The life of a musician is not steady, and
often you do not have money. A musician may have
a wonderful gift and talent that everyone enjoys but
few people are willing to pay for.

*AND DO NOT FORGET TO DO GOOD AND TO
SHARE WITH OTHERS, FOR WITH SUCH SACRI-
FICES GOD IS PLEASED (HEBREWS 13:16).*

Most of the musicians I recall during that
time did not have other jobs. It was only their music
that supported their families. Mama did her best to
help them even though her own family was having
difficulties. Not only did Daddy have a problem with
women, he also gambled, often having no money left
for his family. Mama did not earn a lot of money and
Daddy lost most of what he earned gambling.

My first knowledge of God came one night
as Helen and I stood outside of Mama's bedroom
watching as she knelt to pray. We kept calling her
name and giggling. She told us to stop. She later

explained what she was doing. We never interrupted her again. I cannot recall really attending church with my father. I have been told by my mother that when I was a very small baby Daddy did go to church with Mama and me.

Another fun time I recall was when Daddy was trying to cut the yard and had one of those old push mowers with blades you had to sharpen. We were outside under a tree; I always loved to work outdoors in the yard and I still do. Daddy was telling me how to actually cut a yard and while we were working I started giving him words that I knew how to spell and he would ask me did I know how to spell "pneumonia". I said, "Yes, n-e-w m-o-n-i-a" and Daddy would laugh. It just tickled him. He would say, "No, it is not an "N", it starts with a "P". Eventually, I found the correct way to spell pneumonia that day. Though Daddy could laugh with me; he did not play a lot. He was a very firm person. You knew to respect him regardless of what was going on with him and Mama.

THERE IS A TIME FOR EVERYTHING, AND A SEA-SON FOR EVERY ACTIVITY UNDER HEAVEN: A TIME TO SEARCH AND A TIME TO GIVE UP A TIME TO KEEP AND A TIME TO THROW AWAY (ECCLESIASTES 3:1, 6).

Because of several events that happened in the household, one in particular, Mama became very hurt. She decided that she was going to leave Daddy. She had pretty much had all she could take with what was going on and she was not going to stay with him any longer. But, she had one problem. My older sis-

ter, Helen, became pregnant at a very young age. She was about fourteen. My mother's mother, Rosie Lee Brown, and her father, Will Harvey, suggested that perhaps Mama needed to send Helen Joyce and the baby to live with her father in Louisiana. Helen had seizures since the age of three and she was not physically able to adequately care for a newborn baby. Mama realized that she could not work and care for Helen and the newborn baby. Mama felt that this was best for Helen, the baby (Janice), Mama's two other children, me and Linda. Mama had to find a new job and start over again. So, Mama agreed and, of course, it was not what she wanted to do, but she felt that maybe it would help if she made the transition. Once settled Mama would bring them back to live with us. One day Mama opened a bed sheet and placed it in the middle of the floor of the house and suddenly started piling our clothes in the sheet. She hurried to move. She tied up all the clothing she could gather and put the sheet in the car. Daddy had a green Pontiac. It was one of the cars from the 1950s. Mama loaded that car up then put us in the car. All I can recall now is that we hurriedly moved out of that house. We moved out to an area of Houston called Acres Home. This is where my grandmother and grandfather lived. The next thing I know; we were told we would be staying there for a while. For a period of two weeks I was living in my grandmother's house. The school I had attended in Fifth Ward was no longer my school. I did not have a chance to say goodbye to anyone. I enrolled in Mabel Wesley

Elementary School. I stayed for a two-week period. I was really kind of confused with the change that had gone on and I could not say anything about what had happened. All my friends were at Charles Atherton Elementary School in Fifth Ward.

One day my Daddy visited and he had a smile on his face. He asked me if I wanted to come and live with him. I did not want to say that I did not want to come; I did not want to hurt his feelings and yet, I did not want to hurt Mama's feelings either. I just hated that they were not together. In some ways it still brings tears to my eyes as I go back and recall some things that most times you would rather forget. But that time was so hard for me. I was about ten years of age. I smiled at him, but remained with my mother. Later, I remember telling my Mama that I knew she loved Daddy and I was questioning her about staying with him again. I sensed that I had touched a tender place within her and although I knew she was angry with him—she did love him.

Daddy had gone too far this time, however. He had taken Mama beyond what she was able to put up with and still she cared a lot about Daddy. She was tired and she had made up her mind that she was not going to continue the marriage under those conditions. She had suffered for more than thirteen years. We continued to stay with my grandmother. My mother and Aunt Lillie would often get together. Aunt Lillie, who was such a comical person, really kept my Mama encouraged and she helped Mama get

through this difficult time. Aunt Lillie was more of a sister to Mama than any of her other aunts.

Mama stopped singing and found a job providing childcare for a family. She took care of two small children while their parents worked.

Mama needed to find her own house. We could not continue living with my grandparents. One day Mama and Aunt Lillie started walking in the Fifth Ward neighborhood and as they were walking they saw a house for rent. This is where the story of my life with the Reverend Ernest J. Jones begins. He was not a Reverend then. He was just a young boy. He was about fourteen years of age when my Mama went to that house. There she met Mr. Jones, whom we later called "Papa" just like his children did.
His name was Ulysses Jones and his wife was Eunice Jones, whom we called Mrs. Jones. They owned the property in the community and they had this little rent house on the corner of Nichols and Waco Streets; right next door to their own house. Mama was looking for a small two-bedroom house; where she and her girls could move to and she could continue to do what she needed to do for us. She had a plan. She had that little job and she was going to strike out on her own and make it because she knew she had to come out of her mother's house.

While they were visiting with Mr. And Mrs. Jones about the house for rent they were just amazed because the children in that house were so different. They were so mannerly, pleasant and courteous. They had been taught by the love of God how to respond

to strangers and how to make people feel welcomed. They learned this at an early age. When Mama and Mrs. Jones finished talking about the house and they were about ready to leave, Aunt Lillie looked at Mama and said, "Have you ever seen children like these before?" She was amazed because they were so uniquely different. They were really a special family.

After Mama secured the rent house, we moved in and began setting up our home in a new environment. Mama continued with her new job. She had an idea of what her new life was now going to be. After about a month or so, Daddy and Mama started talking and she agreed to allow him to come back to the family. We were a family again. Daddy was trying his best to prove himself and he did all he could do to be a good husband and father. He was happy. Mama would always tell me she never would have allowed Daddy to come back had it not been for me, at least that is what she told me. I often wondered about this.

FOR IF YOU FORGIVE MEN WHEN THEY SIN AGAINST YOU, YOUR HEAVENLY FATHER WILL ALSO FORGIVE YOU (MATTHEW 6:14).

Daddy enjoyed being around people. He was a regular guy. He was from a very unique family with a very good family background. Most people would say he was the "black sheep" of the family because he was nothing like the others. They were very proper and very social, just totally different. I guess some

people would call them a "silk-stocking" group of people, but Daddy was more of a street person who loved everybody. Ernest said he used to enjoy working on the car with Daddy just laughing and talking.

For a good four months we stayed there in harmony and there was a lot of pleasure. One day, Christmas of 1957, Daddy took me and my sister along to visit his mother and family in the Studewood Heights section of Houston. We walked the two blocks on East 32nd Street talking with everybody and just saying hello to all of the family. He made a full round while Mama stayed home resting because she was so tired after cooking and taking care of the holiday preparations for the family. We were out having a good time. We finally headed back toward home and Daddy was driving very fast. Later that day, Daddy went out with friends and that was the last time I saw my Daddy alive.

At the club, the owner and his son were involved in an argument. The young man was threatening to kill his father. The young man had been drinking and was accusing his father of having a relationship with another woman. The son was upset and got a gun to kill his father. Daddy saw what was happening and held the son to keep him from shooting the father. The son continued to consume alcohol and stated very boldly that he would either kill his father or the one who had held him. During this time Daddy had left the club. The son followed him outside the club and shot Daddy. One of the bullets

entered Daddy's shoulder and traveled to his heart and killed him instantly.

This was the beginning of a great transition for the family. Four days later we buried Daddy on December 29, my eleventh birthday. I did not have a birthday party that year. We were all so sad and down-hearted. One thing I remember that stands out even today is that was the first and last time I ever saw and hugged my father's father, Ed Johnson. He was a barber and lived in Nacogdoches, Texas.

As time went by, I would listen to a popular song called "Always" and it goes like this:

"I'll be loving you, always,
with a love that's true, always.
Not for just an hour, not for just a day,
not for just a year, but always."

I do not remember all the words but I played that song over and over. I would sit back and think about Daddy and sometimes the tears would flow, because a girl does need her father. I really loved my mother, but I loved my Daddy too. In spite of how he was, and the things he did; I loved him and missed him.

I TELL YOU THE TRUTH, YOU WILL WEEP AND MOURN WHILE THE WORLD REJOICES. YOU WILL GRIEVE, BUT YOUR GRIEF WILL TURN TO JOY (JOHN 16:20).

I continued to grow up right there in the yard with "Papa" and Mrs. Jones and their family. My mother and Mrs. Jones became very, very close. There was also a girl in that family. Her name was Han-

nah. Hannah was short in stature. She was the only girl in the family at that time. There were five children Ernest, Nobleton, Hannah, Ulysses and Eddie. When we moved four years later another child by the name of Marie Julia was born. Eddie, who was the youngest at that time always played with my sister, Linda. They were around the same age. They always enjoyed each other. Once when they were playing, something happened and Linda pushed Eddie out of our back door throwing his cap behind him. Eddie was looking so sad as he stood on the sidewalk. He looked at Linda and said, "Linda, you know I love you." Mrs. Jones and Mama still laugh about them today.

Hannah and I became very close friends, just like sisters. I guess I fell in love with Hannah and felt about her as I would another sister. I always felt as though I was a part of their family. They were such a big family, a fun family, and "Papa" was a strict male figure. Papa stood tall and when he said something, he meant it and you knew it. He was very firm and at the same time very loving.

One of Hannah's chores was washing dishes. She always had to wash the dishes and Mrs. Jones would be in the kitchen as well, cooking, and she would tell her, "Now Hannah, you need to get them dishes done, darling, 'cause your papa wants them dishes done and you are going to be in trouble if you do not go on and get it over with." So, Hannah would be struggling to do the dishes and I would go in the kitchen and could hear Papa call out, "Hannah, you

through with those dishes yet?" Well, she would say, "No sir, Papa," and he would say, "Girl you get 'em finished."

Oh, God! I would say to myself, afraid for my friend, and then I would ask Hannah if she wanted me to help. She would eagerly accept my help. So I would get in there and try my best to help Hannah wash those dishes. It just seemed when Hannah needed help I was there. Sometimes Hannah would call me just because she knew I would come. She began to use me to help her wash dishes because she hated that job! While I was there I enjoyed being around and I always knew Ernest, Hannah's brother, would be there. Sometimes he would come in the kitchen and he would tease me a little bit and kind of give me a soft smile and I would kind of smile back at him. I was a bit shy. Ernest was a big boy, and being older, he did not hang around us younger kids too much, but he was around enough that he noticed me and he would say something like, "Watch the Birdie." He would tease me and I would kind of laugh or hit at him. Hannah would say, "Now, boy, get out of this kitchen," and she would put him out. She reminded me not too long ago, "Birdie, do you remember when you told me you were going to marry Ernest?" I said, "What?" She said, "Remember I told you he isn't even cute!" I vaguely remembered. We both laugh about that now. I enjoyed being in that kitchen with them. There was something about being in that house. There was a lot of laughter; a lot of fun. The family was together and they loved each other.

On several occasions my mother and Mrs. Jones would wash their clothes and would hang them on the line as they talked. They were like two young girls together and they enjoyed each other's company. Mrs. Jones was not a person who acted as though she was better than anyone else simply because she owned the house we lived in. She was just like my Mama's sister. She communicated with her the same way I hooked up with Hannah. Mama and Mrs. Jones had a good relationship and they talked all the time.

At the age of twelve I enrolled in E.O. Smith Junior High School. Ernest had left E. O Smith and gone on to Wheatley High School. I had lots of friends and enjoyed Home Economics class. During my second year I became Captain of the first Mustang Majorettes. I became very good at twirling the baton. There was another boy in the neighborhood whose name was Loveberry Johnson. He was tall and good-looking. He had kind of curly hair and he could hold you spell-bound because he acted very mature for his age. Even the elderly neighbors were fascinated with him. He would come by my house on his way to school and would stop and we would walk together. I felt kind of special at that time. We would walk from Nichols Street to Lyons Avenue and down Lyons all the way to E. O. Smith Jr. High. We enjoyed walking and talking and having a good time. My mother and Mrs. Jones would be outside watching us as we left for school.

One day Ernest hurried me to leave for school earlier than usual. I recall him calling out to

me, "Come on out here; let's go! It is time to go to
school." Well, when Ernest would speak everybody
would move because Ernest was kind of like Papa,
he was a big guy and you just did not argue with a big
guy. Whatever he said was meant for everybody. He
just took charge and he is still like that today. He said,
"Come on," so, I hurried to get my books together
and rushed out the door. Mrs. Jones and Mama were
out talking and I did not really know what was going
on. For a couple of days Ernest walked me as far as
Lyons Avenue. He then went on to Phyllis Wheatley
Senior High School and I went on my way to E.O.
Smith Junior High School. He went to the left and I
went to the right. So Mama and Mrs. Jones laughed
about it because they knew Ernest was making sure he
walked me to school before Loveberry did. It seemed
like he was guarding *his* property, but, actually no
special relationship ever developed between the two
of us. By the same token, his parents and mine were
careful that we never did get together either. During
that time boys and girls were watched a lot closer
than they are today, so they kind of kept a hand on
us by keeping us busy. We always had something to
do!

We grew up and time went by as we continued
having good times together. Our families continued
to interact. Papa always kept lots of food growing in
the back yard. He had pear trees, peach trees, plum
trees, fig trees, grape vines and plenty of vegetables.
He was always growing something and always shar-
ing. He had several bee-hives. I remember he had a

jar of honey from one of his bee-hives. It had a honeycomb in it. This was the first time I had ever seen a honeycomb. While standing on the sidewalk he said, "You see this girl. Do you know what it is?"

I said, "Ah, no Papa. What is it?"

He said, "It is honey," and he pulled out that honeycomb and put it in his mouth and chewed it and he even gave me a little taste. I was just amazed by him. He was a big guy, a good man and lots of fun. I was very careful around Papa just like his children. Papa was Papa. He did not play. He was serious. Whenever he spoke to you, he meant business.

Three years after my father died my Mama married again. She married Leo Ikner. He was a very nice man who always showed respect and love toward us. He called me "Big Rooster" and Linda "Little Rooster". Mama always wanted us to have a nice home. She wanted us to have a nicer place than she had when she was a little girl. She wanted us to come from a place that looked like something, so, whenever a young man came to visit us he would realize he was courting someone special.

Right away after Mama and Leo married they bought a home in a section of Houston called Kashmere Gardens. It was about two miles away from where we were living. I did not see Ernest for a long time. I still remember how sad Hannah was the night we moved. I missed them for a long time but went on making new friends. Whenever possible I would continue to visit Papa and Mrs. Jones over the years.

*A FRIEND LOVES AT ALL TIMES, AND A BROTHER
IS BORN FOR ADVERSITY (PROVERBS 17:17).*

I guess I must have been about sixteen when Ernest came to a party I had at my house. At that time he was dating Gwendolyn Balthazar. He was attached to Gwen and I was dating someone else. However, I always kept my eyes on him from a distance. I was kind of curious about him. We went our separate ways and I did not see him for a long, long time after that. I continued going to school. He graduated and after a time I lost track of him. I did not have much communication with him or his family. I was very busy with my own life, remained active in school and continued performing as a majorette; enjoying those years. I was not as studious as Ernest. He was always an "A" student and I always had to work extra hard and I was challenged when it came to school because I did not really want to study. I did not particularly like academics that much, but I did like extracurricular activities. I continued to do things that I enjoyed until the time came that I graduated from Kashmere Jr/Sr High School.

*FOR I KNOW THE PLANS I HAVE FOR YOU", DECLARES THE
LORD, PLANS TO PROSPER YOU AND NOT TO HARM YOU,
"PLANS TO GIVE YOU HOPE AND A FUTURE (JEREMIAH 29:11).*

During the summer of that year, my father's family moved to Los Angeles, California. They welcomed me to come and live with them while completing my education. In the fall of 1964 Mama put me on a train to California to attend college. I enrolled

in Los Angeles City College in Los Angeles, California. After four months I was ready to come back home. I think what I really wanted was to get away. I wanted to see something new and different in my life and I had never been away from home. I was anxious to go for a visit more than I was for an education. I really had no idea of what I was going to become. I was always impressed with my cousin, Glynell, and I looked forward to becoming a teacher like her. But, I knew one thing for sure, whatever else I did, I also wanted to be a wife and mother. I wanted to have a large family. I was more serious about that goal than anything else.

After spending six months in Los Angeles, I returned home. I enrolled in Texas Southern University which is where my mother really wanted me to go from the very beginning. I had been anxious to get away like most teens after graduating from high school—the opportunity to leave town impressed all of your friends.

Mama allowed me to move to California, but, I did not do well there. Maybe I would have done better had I lived in the college dormitory instead of with my father's family. That was not the ideal situation for me. I was anxious to come back home because I was accustomed to living a different way.

After enrolling in Texas Southern University I was not quite certain about what I really wanted to do in college. There were a lot of activities to participate in while you were establishing what you wanted to become. There were all kinds of activities to stimu-

late your interest. The favorite place for most college students was the "Rec". There you could eat in the cafeteria, hang around the bookstore, or hang in the foyer and talk with the students from other places. There was always some group pledging for a sorority or fraternity. They would do all sorts of strange things during their trial period. I would stand there in the "Rec," which served as the Student Union, and observe what was going on.

I spent a lot of time at the "Rec" and sometimes did not go to class. I did not have the kind of discipline that I should have had because I was spending Mama's money to attend college. I just did my own thing more or less. I did not get into a lot of serious things but I should have concentrated more on subject matter. Anyway, I did become a majorette and that was something I had done in high school so I loved it. I loved to twirl the baton and march. I did make the team but failed to make the grades. During that time a favorite song was "Goldfinger", the theme song from the movie of the same name. We did special dances to the music and people would scream and holler. It was really great marching with the school band. You became very popular with a lot of people because they saw you performing. I spent time with the juniors, sophomores and seniors. I had a lot of interaction but I did not have a friend that could help me balance what I needed in life. I kind of drifted away and lost interest in school.

Chapter Two

Do not be yoked together with unbelievers. For what do righteousness and wickedness have in common? Or what fellowship can light have with darkness? What harmony is there between Christ and Belial? What does a believer have in common with an unbeliever? What agreement is there between the temple of God and idols? For we are the temple of the living God. As God has said, "I will live with them and walk among them and I will be their God and they will be my people (2 Corinthians 6:14-16).

ONE day I met a girl named Erma. She lived with her husband, Lynn, across the street from my own home. She and her husband were going to a club on that particular weekend and encouraged me to come along also. That was the thing to do during that time; go to a party or club. There were lots of little clubs around and of course I wanted to go and did. I did not know on that particular night that I would meet my husband-to-be. I loved to dance and still do, and

while I was on the floor dancing I guess he noticed me. I did not know that he was there with Erma and her husband. They had arrived before me. Sometime during the evening I was introduced to Bob Isaac and I was invited to join them at their table. He was good-looking. That is one of the things that attracted me to him. He had beautiful eyebrows and he was "built" as girls said back then when a man was muscular and trim. I was attracted to him and later on we started to talk and began to date. Bob had been married before and was divorced. He also had five children during his previous marriage. My mother was not very happy about me seeing a divorced man with so many children. At age eighteen it is hard to control a young woman and direct her in the way that you want her to go. My mother had difficulty with me because I was kind of head-strong about what I wanted to do. She would often say that if my father had been living she would not have had any problems with me.

Bob and I continued seeing each other regularly. I did not realize that he was recovering from the relationship he had with his first wife. I found out during that time that there were five children in his marriage. His position was that two were definitely his and the other three she had during the time they were married and were possibly not his. He had a very difficult time in that marriage and was still carrying lots of baggage.

Our relationship moved rather fast. I did not see any of the important signs. Three days a week I worked at Foley's of Houston in the customer service

department and I was beginning to get a little independent but, I did not really know what to do with my life or how to do it. When I look back at that time I realize I was experimenting with life. I made a step and that step was to marry.

I dropped out of college and married Bob after just turning nineteen. He really was not prepared to be a husband again. We did not have a house of our own or even an apartment to live in. He was living with his mom and when we married I ended up moving into the house with both of them. Three months later we found an apartment and moved out on our own, so the plan was really off. I mean we had no idea about what we were going to do. We never received any marriage counseling which might have changed my perspective at that time. We had a pretty sizable wedding which exhausted all the money we had. A couple of days after the wedding we were left eating hamburger meat because we really did not plan ahead. When I think about it, we were just so foolish. I was looking for an escape, an opportunity to be on my own. But instead of striking out on my own, I ended up married to a man who was a very nice person but he could also be a very ill-tempered individual.

My marriage in a lot of ways became very abusive. I think a lot of the anger Bob had toward his first wife he took out on me. After a year Bob was faced with constant threats for child support. He was not making very much money because he had no special skills. His mother suggested that he try

moving to Chicago, Illinois with her brother, Leroy, for a fresh start and no hassle. It was in Chicago that I really went through a lot of changes. There was a lot of fighting. It was almost like my early life as a little girl being repeated. I really thought that this was the way husbands and wives lived because I had experienced hardships early in life. I did not have a strong image about a family that loved one another so deeply that there was a lot of hugging and kissing and positive communication between husband and wife. I just thought this was the way married life was. We would constantly fight and then make up. There was always a plan after talking for making things better but the situation never changed. My husband had this attitude of competitiveness with me and no matter what I would attempt to do he would try to do the same thing to show me he could do what I did and more. That continued for over eighteen years. After a period of time it seemed like the little love I had for him was lost. The more we would fight it seemed the angrier I was and the further I pulled away from him. I should have left him the first year and definitely after the seventh year. I wasted years trying to make a dead marriage work.

During the Christmas season of 1969 I applied for work with the postal service as a clerk and I successfully passed the required exam. I did not like the job but the money was great. After two years I started to feel that I wanted to do something else. I then re-enrolled in college. This time it was at Malcolm X Junior College. I earned an Associate of Arts degree

in Early Childhood Development. One semester after I enrolled in Malcolm X Junior College, Bob also enrolled. We graduated together. I graduated with honors. We had hopes of maybe opening a daycare center, but that never happened. For two years I operated Isaac's Soulful Tots Day Home from our apartment. My work hours were long and I did not have enough helpers. In 1971 I sought employment with Lawrence Armour Day School as a teacher. It was a wonderful facility. I enjoyed working with my class which consisted of children from around the world. Bob became a childcare director for Christian Action Ministries. He enjoyed his job but still enjoyed and loved the world. He was doing things he should not have been doing and a lot of it I did not understand.

During those years many people smoked pot, dropped pills and they were having a good time. They did their own thing no matter what. He was one of those people who tried some of everything. I would not participate in his drug experimentations. He became very disenchanted with life. After living in Chicago for almost ten years we moved back to Houston and started over. Bob found employment as a laborer and I began working in childcare. In coming back to Houston I had hopes that maybe our life would become better but it did not. I had abdominal surgery three months after returning home. Once again, not to be outdone, Bob decided he needed foot surgery two weeks after my surgery. I had a hope that this time things were going to get better, but as time passed the arguments and competitive spirit

would always spring up and the fighting always reoccurred.

I always loved and wanted children, but I never became pregnant. It was discovered after surgery that I could not have any. So, I gave a lot of love to children belonging to others and my own family members. I had not been very active in church for almost ten years in Chicago. But, in coming back to Houston, I found myself going back to church and getting involved as I was before we married. Bob did not like it. He was jealous, very jealous. I could not convince him that there was nothing going on at church. He accused me of being with every man from the preacher to the maintenance man. As I have stated, he was very competitive. He decided he would come and join the church. He was baptized just to prove to me that he could do that, too.

THE ACTS OF A SINFUL NATURE ARE OBVIOUS: IMPURITY . . . IDOLATRY . . . HATRED . . . JEALOUSY . . . SELFISH AMBITION . . . AND THE LIKE. I WARN YOU THAT THOSE WHO LIVE LIKE THIS WILL NOT INHERIT THE KINGDOM OF GOD (GALATIANS 5:19–21).

However, Bob could not hold out. He was appointed to an office in church. It was President of the Brotherhood and Women's Uplift and he stuck with that for maybe three or four weeks and then finally disappeared. He was hanging out with some guys from his job and left the church. After a while he lost his job, too. He was always trying to get more money and he wanted to earn top dollars for labor that he had not done for a long period of time. He

was laying tile for a company and was convinced he should earn top dollar for his labor. He would go from one place to another and when the job folded he had none. Bob grew so bitter that even his facial expressions changed. He was seven years older than me and was going through midlife crisis. He looked at his life and knew things were not right and would become very disturbed when he wasn't where he felt he ought to be. He seemed anxious to achieve/own something but he turned against the one who was willing to help—me!

In his bitterness he totally turned against me. Our life together was not good. Finally, I began to leave home. The first time I stayed a day with my sister, Linda. Bob came after me. The next time I stayed away and was gone for two days. Finally, my mother said she recognized when I began to leave that it was a sign that I was really about to leave him for good. We had been married for eighteen years and finally we separated. I left the house in which we lived which was next door to my grandmother. She was very upset because she felt I had worked hard and purchased all the furniture for the house. But, I just walked away from everything. She could not understand why I would just leave like that. But, you know, when it is time to go—it is time to go. It really did not matter about the furniture because I had the mind-set that I could buy new things. I started my life anew.

I did not know what I was going to do, but I did know I could not stay any longer with Bob, and

I was not going to continue my life as it was going. I was still active in church and loving every minute of it. The Lord had opened my eyes. I hated so much that I was divorcing, but I had made up my mind. I knew I had to do it. For almost three months I lived with my mother and Bob remained in the house we had rented together. During this time I worked for Houston Gulf Coast Community Service Project Head Start Program as an Education Coordinator. My salary was very low but I had a job. It was during this time my sisters, Helen and Linda and niece L'lana rented a Lincoln Continental and we departed for the World's Fair in New Orleans, Louisiana. Our trip continued to Atlanta, GA. It was in Atlanta that I first saw a woman minister in the pulpit. I was very impressed.

FOR NO WEAPON FORGED AGAINST YOU WILL PREVAIL, AND YOU WILL REFUTE EVERY TONGUE THAT ACCUSES YOU. THIS IS THE HERITAGE OF THE SERVANTS OF THE LORD AND THIS IS THEIR VINDICATION FROM ME (ISAIAH 54:17).

A few days after returning from our trip, I went to the house to get some of my things. When I arrived, Bob was outside mowing the yard. My oldest sister, Helen, was with me. I made sure I had somebody with me because I knew if I went to the house alone something would happen. When we arrived, I attempted to open the front door but he had changed the locks on the door so I could not get in. He did allow me to enter the house through the back door. Once inside the house I noticed a key hanging in the dead bolt lock and, of course, when I saw it, I

pulled the key out and I hurried to get what I needed. Moving swiftly outside the house he looked at me and rushed inside realizing what I had done. He was really mad. I told him goodbye, got in the car and we left. Well, it must have been two or three weeks later I received a call that he was leaving. He said, "You can have everything in the house. I am taking my truck and my tools and I am leaving." When he called I had been looking for a place to live. I was afraid he was lying so I waited a few more days before going back to the house. He did leave and he left his keys with my grandfather next door. So I finally moved back into the house three days later.

I was not making a lot of money and I had a car note and I was scared to death. I had never lived by myself, and I was not accustomed to being alone. For three months I went from leaving every light in the house on to finally turning all the lights off. You know, the Lord is really wonderful. He will keep His word to His children. He says:

> *SEEK YE FIRST THE KINGDOM OF GOD AND HIS RIGHTEOUSNESS AND EVERYTHING WILL BE ADDED" (MATTHEW 6:33).*

I continued in the Word and I continued going to church. I went on doing what I could and I had help from my grandfather and grandmother. My sister, Linda, who was a police officer at the time and my mother, would help out. I learned to manage on my own. I did things I should have done eighteen years earlier. I learned how to manage and live the

single life. I met lots of people along the way. Every experience taught me something valuable about people. I came to realize everybody in church was not saved and to put my trust not in man but in God.

THEN HE OPENED THEIR MINDS SO THEY COULD UNDERSTAND THE SCRIPTURES (LUKE 24:25).

Living alone, I grew closer to God. One night as I sat listening to Gospel music on my radio, Rev. Al Green was singing a song "Holy Spirit Come Down On Me." I began to ask what is this "Spirit" he is singing about. Suddenly, I heard a very sweet soft voice say, "Ask for it." A few days later I went to First Shiloh Missionary Baptist Church and sought council with assistant pastor, Lee Williams. The Lord had placed fasting and prayer on my mind. Rev. Williams provided confirmation as to many types of fasts. I left his office and at 12:00 midnight I began a three day fast for the Hoy Spirit. I read constantly the book of Acts as I prayed. In the last day of the fast God revealed a vision of a woman running to a labor room. As a sheet was lifted from her body, I sat up in my bed. My body was somewhat weak, but it tingled all over. I later spoke with my mentor mother, the late Helen Minor, who worked with me at the Project Head Start. She interpreted the vision although I still did not fully understand what was happening. For three months I performed services to others as the Holy Spirit led. It seemed I was tested for proof of my commitment.

*WHEN THE DAY OF PENTECOST CAME, THEY WERE ALL
TOGETHER IN ONE PLACE. SUDDENLY A SOUND LIKE
THE BLOWING OF A VIOLENT WIND CAME FROM HEAVEN
AND FILLED THE WHOLE HOUSE WHERE THEY WERE SIT-
TING. THEY SAW WHAT SEEMED TO BE TONGUES OF
FIRE THAT SEPARATED AND CAME TO REST ON EACH OF
THEM. ALL OF THEM WERE FILLED WITH THE HOLY
SPIRIT AND BEGAN TO SPEAK IN OTHER TONGUES
AS THE SPIRIT ENABLED THEM (ACTS 2:1-4).*

On December 3, 1984, after three months of
constant ministry to others, Dr. C. E. McClain was
praying before we received the Lord's Supper. I had
been fasting before the service and when he said,
"Let us bow in prayer," my whole body went totally
limp and I could not move. Suddenly, I heard a very
sweet voice which instructed me: She said, "Let
them hear the beauty of the voice as it is intended."
I started moving my lips saying, "Hallelujah, thank
you, Jesus." Something began to cover me from my
feet to my head. I began to speak in tongues and
became quite loud. When I opened my eyes Pastor
McClain was still praying. My grandmother was
seated next to me and did not seem to understand
what was happening. One of the church missionaries,
Sis. Ruby Lee Kirby, came over and began to shake
me. I can still recall her saying, "This is nothing but
her divorce causing this." As I tried to talk to her I
could only utter in an unknown tongue which I had
absolutely no power to stop. I was removed from the
service and placed in a chair but found myself on my
knees worshiping God. I was moved again and put
in a wheelchair as they rolled me to the back of the

church; I began speaking the same words, "Hallelujah, thank you, Jesus." My grandmother had called for someone in the family to come and pick me up. When my sister, Linda, and cousin (now deceased) Rosie B. arrived, they said I had a glow on my face. Rosie B. told my grandmother "Aunt Lee, you know what this is—you received it."

FOR JOHN BAPTIZED WITH WATER, BUT IN A FEW DAYS YOU WILL BE BAPTIZED WITH THE HOLY SPIRIT (ACTS 1:5).

After realizing I was alright Pastor McClain sent missionary Bertha Gatterson to bring me back. He wanted to know what had happened to me. A few days later he announced his call to another church. That night when I met with him again, I told him that before receiving such a blessing from God I could not have accepted him leaving, but God had given me strength to rejoice in his decision.

The Lord poured out a shower of blessings upon me and clothed me with power from on high. I learned that Jesus Christ Himself did not enter His ministry until he had been anointed with the Holy Spirit and power (Acts 10:38-Luke 4: 1, 18).

God also put it in my heart and mind to become a tither and I did. My grandmother told me, "If you tithe you will never want for work. God will always make provision for you." I believed her then and still believe it today. I have watched how greatly He has blessed my life through giving. I tithe regardless of any circumstances before me. I often heard

others say, 'Give until it hurts," and I did without any regrets.

Although my finances were small, I bought a new 1988 Toyota van. I became very confident in God's word. I went back to Texas Southern University, attending classes during my lunch hours and after work. I also had independent courses. I was blessed twice, making the Dean's List for honor students— then in May 1987 I received my Bachelor of Science Degree in Early Childhood Development. The Lord placed me right back where I was when I first met my ex-husband. He put me right back in the college I was in before marrying. I completed that course of life. It was as if He had returned eighteen years of my life. I was given a second chance. He gave me a new strength. In the past I was really very weak. I had no real sense of direction. Without God and the leading power of the Holy Spirit I was lost. I came to the realization that I had made mistakes earlier in life because I was not allowing God to lead my life. I did not seek His perfect will for my life. Having received the Holy Spirit I did learn that I could go to God and make my requests known. I learned more about fasting and praying; how to seek God for things that I needed with confidence He could and would provide according to His will.

I grew stronger daily, much stronger in my faith in God. I did not stop with my Bachelor of Science degree. In the fall of 1987 I immediately enrolled in Texas Southern University's graduate program

seeking a Masters degree in Early Childhood Development with a "Kindergarten Endorsement".

Then, seeking God for direction, I dropped out of TSU to answer a greater call. I announced my evangelistic call before the congregation of First Shiloh Missionary Baptist Church. During the early '80s women ministers were not accepted or easily received by most denominational churches. Rev. Sam Robinson, an associate minister in the church, encouraged me to accept the calling on my life. I was placed on a thirty day wait for acceptance. In the end, I received prayer before the congregation, but, I was never permitted to function as an associate minister.

IN HIM WE WERE ALSO CHOSEN, HAVING BEEN PRE-DESTINED ACCORDING TO THE PLAN OF HIM WHO WORKS OUT EVERYTHING IN CONFORMITY WITH THE PURPOSE OF HIS WILL, IN ORDER THAT WE, WHO WERE THE FIRST TO HOPE IN CHRIST, MIGHT BE FOR THE PRAISE OF HIS GLORY (EPHESIANS 1:11-12).

I continued working in the church heading the Emergency Relief Program. It was through this program I did the work of an evangelist. My pastor, Rev. Dr. Donald Ray McNeil encouraged me to attend seminary. He also sought to get a scholarship for me to attend seminary in St. Louis, Missouri. I did not feel that this was God's desire for me. Pastor had ordained five women while in another state. My trust level was not to allow anyone to take me off the path of God's plan. I never gave up. I knew there was a seminary in Houston designed for me. With the help of Rev. Sam Robinson, I visited three schools.

My final school to visit was the Houston Graduate School of Theology. We were invited to spend an hour in Dr. Robert Worden's class. I was very impressed and I knew this was the school I wanted to attend. God had sent me there. Many well-known ministers in the city of Houston were enrolled there. It was greatly represented by different ethnic groups. This school represented the kind of church I hoped to one day pastor. The classes were very expensive and after my first semester I applied for a student loan which became my only financial hope of remaining in school.

> *HOWEVER, AS IT IS WRITTEN: NO EYE HAS SEEN NO EAR HAS HEARD, NO MIND HAS CONCEIVED WHAT GOD HAS PREPARED FOR THOSE WHO LOVE HIM— BUT GOD HAS REVEALED IT TO US BY HIS SPIRIT. THE SPIRIT SEARCHES ALL THINGS, EVEN THE DEEP THINGS OF GOD (1 CORINTHIANS 2:9–10).*

Chapter Three

ONE year before I began searching for a seminary, I had attended a special service in Baytown, Texas. It was hosted by Evangelist Gail Patterson from Greenfield, Mississippi. Services were spiritually very high as we worshiped God. Evangelist Patterson called me to come forward for a prophetic word from the Lord. She said: 1) "I would be like her;" 2) "Someone in my family would help with my ministry;" 3) she saw me " . . . sitting at a table with books all around me;" 4) "Within four days I would have a supernatural vision following that service."

The vision came and I returned to the Crusade to confirm her word. The name of God's given ministry was revealed to me "God's Way". I focused greatly on serving others and seeking to encourage others to receive Christ as their Savior. God equipped my call with necessary gifts used often in and outside of service. One night as I sat in class at the seminary, Evangelist Patterson's words came back to me. We (ministers) were seated around a large table with

Bibles open, discussing the Word of God. Every thing which she prophesized had come to past, except the prophecy that related to someone, who would help me in my ministry. I thought perhaps it would be my niece, L'lana or her daughter, Breiana, but it seemed that the ministry was not developing as I expected.

In June 1994, my grandmother Rosie Lee Brown died. In July of the same year, I attended a Shirley Caesar Conference in Memphis, Tennessee. I fell in love with the Tennessee countryside. I had a wonderful time although I was grieving over Nanny's death. God sent messengers during that conference that helped to lift my spirit. I joined the conference choir which was directed by the late great O'Landa Draper. I was blessed also to sit on the stage with many great ministers of the Gospel such as Bishop T. D. Jakes, Shirley Caesar, Rev. Ernestine Reems, Bishop Patterson and numerous others whose presence enlightened the service nightly. Although I was not known by them, God purposed my position among them not only for me to taste and see His goodness but in the last night of service when the minister requested every minister seated on the platform should give one hundred dollars. I asked God what amount I should give and followed His instruction. As I was the first minister to place my offering at his feet, Reverend Campbell announced that the evangelist, (speaking about me), has given one hundred and twenty-five dollars. God used my offering to teach others how to obediently and sacrificially

give. Everyone in that service came forward with an offering.

One morning as I was standing near one of the classrooms sharing with others, a young woman noticed a picture of Breiana attached to my key chain. She began to say how pretty she was, how she would one day dance for the Lord. She also said that Breiana would bring much joy to our family. What was spoken confirmed my thoughts. I knew there was something very special about her the day she was born. During her birth I was privileged to cut her umbilical cord. I knew L'lana was her birth mother but this baby belonged to me and one day would be the next evangelist in our family.

On another evening after service, I joined several women ministers who had spent years delivering God's Word and they shared the goodness of God with me. Evangelist Tucker, who was the grandmother of Shirley Caesar's god-child told me that God was about to pull me out of my church. I received what was said and went back to my room. Three months later I was led to join Good News Church pastored by Apostle Dorothy Washington in Missouri City, Texas. This church was twenty-three miles one way from my house. Pastor Washington lovingly received me knowing I had been given a ministry, "God's Way Ministry" which needed positive mentoring. At that time Pastor Washington became my mentor as well as my pastor. The church followed Psalms 150. It was not church as usual. I was a member of Good News Church when I graduated from the seminary.

Pastor presented me with a very nice Bible which I use very often in worship and study today.

It was also during my service at Good News Church I endured great suffering on my job. Along with others, I filed a discrimination law suit against our employer, Gulf Coast Community Service Project Head Start. It was also during this time that I met Donald Scott. One day after church services, I decided to drop by Janice Wilson's home. She is the sister of Donald Scott. I stopped so that she could see my great niece, Breiana. Donald was visiting her for the weekend. We all shared for an hour or so. After a while I left to return to my house. Somehow, later that evening I talked with Donald by phone. He was preparing to return to his home in Dallas, Texas. Two weeks later, one evening while talking, we started talking about my graduation. I had not been able to find anyone with a camera or video recorder and I really wanted some nice pictures. He eagerly responded that he had both and he would come to the graduation just for that purpose. I could not believe it. He did not know anything about me except the fact that his sister and I were good friends and co-workers. I called Donald a few days later giving him the graduation schedule. From there a new relationship began. I knew he had been married before and had two daughters whom he loved greatly. After graduation we spent a great deal of time talking and on weekends he would drive down to Houston to attend church services with me, and take me out to dinner. We enjoyed each other's company as he helped to

take away the pressure caused from my employment. It was Pastor Washington who encouraged me not to quit my job when we were forced to teach in the Head Start Centers.

I continued to minister. In 1995 my job was downsized. I was encouraged still not to quit my job, but to work as a teacher in a Head Start classroom. Donald always encouraged me greatly and told me not to worry. Donald continued to visit on weekends and he loved to shop at Wal-Mart. It was Donald who taught me how to make homemade fudge. He would often send roses to my work place. He was well loved by my family and Mama had hopes that we might marry and I would perhaps move to Dallas. She often told me she was concerned that I did not have a family of my own. While the Gulf Coast Community Service Project Head Start Program was under Federal investigation, my job as a teacher was purposefully made to be very difficult. However, God always shares his plan with His prophet.

SO DO NOT FEAR FOR I AM WITH YOU; DO NOT BE DIS-MAYED, FOR I AM YOUR GOD. I WILL STRENGTHEN YOU AND HELP YOU; I WILL UPHOLD YOU WITH MY RIGHTEOUS RIGHT HAND (ISAIAH 41:10).

One day as I prepared for my lunch break, the Lord directed me to dine with Him. Seated in my vehicle, I opened my Bible to the book of Joel, chapter 3. There God reassured me I would return to my appointed position in the education department. God's promise was fulfilled about three months later. I was told that the Policy council had voted for all

education coordinators to return to the central office. In the midst of waiting for my call to return, I received an urgent call from Dallas. Donald had been found in his home dead. He had not reported to work nor called in about his whereabouts. During the summer of 1997 he had had emergency triple cardiac by-pass surgery, but had recovered and returned to work.

> *YOU HAVE PLANTED WICKEDNESS, YOU HAVE REAPED EVIL, YOU HAVE EATEN THE FRUIT OF DECEPTION, BECAUSE YOU HAVE DEPENDED ON YOUR STRENGTH AND ON YOUR MANY WARRIORS (HOSEA 10:13).*

It was during the time of his surgery, I found out that he had not legally divorced his wife but was separated. I do not believe he was aware of the pain caused by his not telling me about his marital status. He often talked about getting married and I would tell him perhaps in ten years. Before his death, however, he asked me to forgive him for not telling me the entire truth. He was in the process of correcting the situation and returning to work. We had talked the day before his death and I reminded him that Breiana's birthday was the next day. It is true Satan comes to kill, steal and destroy. Donald's death was very difficult for me because I had to endure what I felt was his deception, my unforgiveness and love for someone who was my best friend during my worst time. I also hurt because I did not have the chance to say goodbye. I really cherished my feelings for him.

For almost two years I was in a very deep dark place.

*THEY SOW THE WIND AND REAP THE
WHIRLWIND (HOSEA 8:7).*

It seemed people around me did not know I was one step from a mental institution. I masked my pain by changing my hair color to a very bright blond color. Three years after his death I revisited Donald's place of employment and his final resting place. I had not been able to return since he had died but God allowed departing service just for me. It was really for closure. As I left his grave Gospel singer Evelyn Turrentine-Agee was singing "Till We Meet Again" on a CD in my vehicle. I left his grave covered with rose petals and a dozen roses resting in his flower urn. I felt comfortable in knowing that he is definitely in the arms of God and all is forgiven. I finally said my goodbye "Till We Meet Again".

*BUT THOSE WHO HOPE IN THE LORD WILL RENEW
THEIR STRENGTH. THEY WILL SOAR ON WINGS LIKE
EAGLES' THEY WILL RUN AND NOT GROW WEARY, THEY
WILL WALK AND NOT BE FAINT (ISAIAH 40:31).*

In December 1998, after 21 years of employment with Head Start, I became unemployed with 491 other colleagues in Head Start. After the Federal investigations were completed, Gulf Coast released 70% of their program. That 70% portion would be maintained on an interim basis by William Smith, Sr. Tri-county Head Start for a period of one year. After that year three new agencies assumed the 70%, however, very few of the old employees were retained by the new agencies.

When the world throws lemons your way, you learn to make lemonade. For one year I drew unemployment compensation. Unable to get regular work, I started Neighborhood Orientated Child Development Resource which provided early childhood training to childcare centers. I was also working part time with two home care programs and also contracted as a Child Development Associate Representative (CDA) for the Council for Early Childhood of Professional Recognition in Washington, DC. Working four part time jobs was not easy but God gave me favor to obtain the finances necessary for me to live. I lost nothing but gained greater faith in God. It was during this time that God lead me to leave Good News Church after six years of service.

WE ARE HARD PRESSED ON EVERY SIDE BUT NOT CRUSHED; PERPLEXED, BUT NOT IN DESPAIR; PERSE-CUTED, BUT NOT ABANDONED; STRUCK DOWN BUT NOT DESTROYED (2 CORINTHIANS 4:8-9).

Looking at my new life, one factor remained unchanged. I was still living in the rent house where Bob and I lived before our divorce. I wanted a better home. I wanted to own something. I started seeking to purchase property. My parents had a rent house which I purchased as a means of financial security. I was very happy and began to have a sense of accomplishment. Still desiring a new home, I purchased a sizable lot across from where I lived. I began to seek a contractor for building a new home. However, I constantly ran into stumbling blocks. It seemed that the more I attempted to build, something would happen

preventing my progress. After months of attempting to build, I came to the point of giving up. For months I had wanted a new bedroom suite. I decided not to wait any longer. I purchased a large king sized sleigh bed which I planned to put in my new home in the future. Philippians 4:12—the Apostle Paul states "I have learned the secret of being content in any and every situation, whether well fed or hungry, whether living in plenty or in want." I accepted the state I was in and became happy where I was.

Let us not become weary in doing good, for at the proper time we will reap a harvest if we do not give up (Galatians 6:9)

Sudden changes began to take place with my employment. I lost contracts which affected my finances greatly. It was like somebody was closing down my life. Little did I know that I was being prepared for a new life? My mama and I would talk daily and she would always encourage me as we talked about my future. I was blessed to continue working at Teeter Totter Village. It is a 24 hour childcare center located in the Sunnyside area of Houston which is just south of downtown. My job entailed coordinating their programs. I was doing all I could to make the facility the number one in the city. I spent more time at the job than I did at home. During that time I united with Harvest Time Fellowship securing a covering for God's Way Ministry. At Harvest Time I began to grow through the teachings of Bishop Shelton Bady. It was a wonderful experience for me as I

continued to labor and seek God. Sometimes I would stand in the door of my house and tell God, "This cannot be my lot where I am. There has to be more for me. I cannot understand why I cannot seem to get what I want or what I need but I know that You made me a promise. I am paying my tithes. I am doing all the work I can and yet it seems like I am not getting anywhere." I had these thoughts in my mind. I have heard people say that you can not hurry God, you just have to wait. However, I found out that I *could* ask a question. It helped to relieve some of the pressure I was having about having to wait.

However, nothing happened until God was ready for it to happen. I really was not very anxious about anything. I had really given up and pushed my thoughts about marrying again aside. I always wanted to be married again but I had pushed all of that aside. I was just accepting life as it was. It seemed when I left things alone, everything began to happen.

I know it has been said, "Good things come to those who wait"; but Romans 8:28 says, "For all things work together for good to those who love God and are called according to His purpose." I can really attest to that because a long time ago during a revival an apostle gave me a prophetic word. He looked at me and he commented about how I was so much like him. I had a lot of the same kind of qualities he had and the feel that he had for people. He said although I had some areas that could be improved, like everyone else, that "I see something good coming your way—something really good." He never said exactly

what it was but I felt in my spirit that the good thing was real. I really believed there was something good coming. For years I waited for that good thing and I wondered what it would be.

I wondered if there would be someone in my life one day that would help me, be with me. I just looked for all sorts of things. I had no idea of what the prophetic word meant but still I had hope and I was looking for something to happen.

Chapter Four

AND AFTERWARD I WILL POUR OUT MY SPIRIT ON ALL PEOPLE. YOUR SONS AND DAUGHTERS WILL PROPHESY, YOUR OLD MEN WILL DREAM DREAMS, YOUR YOUNG MEN WILL SEE VISIONS. EVEN ON MY SERVANTS, BOTH MEN AND WOMEN, I WILL POUR OUT MY SPIRIT IN THOSE DAYS (JOEL 2:28–29)

YOU know, most times when you forget about what's been said to you, or you throw things out of your mind, is when things began to happen. It is ironic when I think about how I often laughed with my mother because of dreams concerning me she shared with me. Gee, she could really build you up and excite you about the events in her dreams. It was exciting because many of her dreams had come to pass in just the details she saw. I always listened to what she had to say and I also respected those who had a word for me. One Saturday Mama called me and said, "I dreamed about you last night."

"You did", I said.

She said "Oooh, yeah. I dreamed that you got married."

I said, "Oh, alright! That sounds good. That was a good dream you had."

She said, "Yeah, I dreamed you married a doctor."

I said, "Oh, really! That was *really* a good dream."

She said, "Yeah, it was really something, because I do not know where we were, but I know you had married a doctor because he had a stethoscope around his neck and he was wearing one of those shirts that doctors usually wear—kind of like the white coat. I was at the house and I knew you had gotten married because I heard your voice. You were inside the house. I heard you talking and the house was just beautiful. It was beautiful with white walls everywhere and there were so many beautiful things in this house. It was just beautiful. In my dream, I decided to go outdoors and when I went outside I saw your husband and I asked him, 'Aren't you supposed to be inside your clinic with your patients?' He said, 'Well, when I finish with them I come out here and walk among the people. I said, 'Well, I am getting ready to go back to the states myself.' I watched him as he sat down at a table to eat a hot dog. At this point I woke up.

I said, "Oh, Mama that is a good dream! This is really a good dream. I like that. Married a doctor, huh?"

We laughed and she said, "Yeah, but you know when you dream about a wedding there is usu-

ally a funeral and it is usually somebody very, very close."

I said, "Oh Mama. Good God Almighty, you ruined a good dream. That was really a good dream.

"Yeah, well, I am just telling you that's the way it goes."

So we laughed and kept on talking and finally hung up. I thought about what she had related to me and I called her back and asked her to tell me the dream again and she did. I thought about it. I wondered if the dream was connected to my desire to travel in Jamaica. I wanted to do a special ministry in Jamaica and I thought maybe the dream had something to do with that. I wanted her to give me more details because I had desired to go far away and expand my territory. I had been reading the *Prayer of Jabez.* I hoped that maybe her dream had something to do with it.

However, two weeks later I received a phone call around 6:30 A.M. . My younger sister, Linda, called and said that Mama had called and said that she had gone into the bedroom to wake my older sister, Helen. Helen had a seizure disorder from early childhood. Mama was afraid that maybe Helen was dead but she was not certain. I had to hurry and get my clothes on. I was rushing through my house. I had Breiana, my niece, with me and had to gather her as we drove hurriedly to Mama's house. The ambulance was there when we arrived. When we went inside Helen was in her bedroom on her pillow but she was deceased. She had crossed over. Right away

I recalled the dream Mama had about me marrying a doctor. I thought, *Well, once again Mama told the truth.* The dream was associated with death.

BROTHERS, WE DO NOT WANT YOU TO BE IGNORANT ABOUT THOSE WHO FALL ASLEEP, OR TO GRIEVE LIKE THE REST OF THE MEN, WHO HAVE NO HOPE. WE BELIEVE THAT JESUS DIED AND ROSE AGAIN AND SO WE BELIEVE THAT GOD WILL BRING WITH JESUS THOSE WHO HAVE FALLEN ASLEEP IN HIM (1 THESSALONIANS 4:13-14).

We began to work on Helen's funeral arrangements together and, of course, there were many people to contact and so much to do. I took it upon myself to find Helen's childhood friend that had lived two blocks from Mama's house. I needed to contact her and let her know what had happened to Helen. While out, I happened to pass by Nobleton Jones' home. He is the brother of Ernest Jones. He also lives three blocks from Mama. I saw his truck in his driveway and I thought I should tell him about Helen and he would tell his parents. I was knocking on his door and he came outside to greet me. We began talking and renewing old acquaintances. I told him I had come by to let him know that Helen had died and I needed him to contact his mother and father. I explained how I was going to do it but had difficulty reaching them. As I was talking, he kept staring at me and giving me an unusual look. His eyes kind of smiled all the time.

For years, Nobleton had often stopped by my mother's house and would always say to me, "You know you were supposed to be my sister-in-law."

We did not think a lot about it then, but we would laugh and it would be dismissed. Nobleton was making that statement because our families had grown up together and he knew that I had a little girl's crush on his brother years ago. But, now on this particular day he had a strange look on his face.

He interrupted me and said, "You know I have been thinking about you. For two weeks I have been thinking about you."

I said, "Really?"

"Yes," he said, "you know Ernest's wife died?"

I stopped right in my tracks, "What?"

"Ernest's wife died—died in her sleep," he told me.

For a few seconds I really felt as if I was on a plane that was making a crash landing. I just could not believe what I was hearing. It was like; I just do not believe this. He explained how Ernest went in to wake his wife and she had already died in her sleep.

We continued to talk and I said, "Why didn't you tell me? Why didn't you or someone call and let us know that this had happened? We could have sent him a card or called him or something."

"Well, things just happened so fast," Nobleton added.

"I am so sorry to hear it. I am going to have to do something for him," I said. He told me that Ernest lived in Tennessee and he had been pastoring a church for the past five years. I knew that Ernest

was a minister because years earlier I had heard him preach once in Houston.

We kind of looked at each other again and I said, "I tell you what, I am going to come back or I will call you and I will get his phone number and give him a call or send him a card." I returned to my van and continued on my journey.

Needless to say after talking with Nobleton I really felt nervous. I was a little hyped up. I was exhausted with funeral arrangements for my sister but somewhere in the back of my mind this new information hit me like a ton bricks. Ernest was a doctor! After graduating from college, Ernest left Houston and went to South Dakota where he had a job. He did return to Texas but not to Houston. He went to College Station for graduate school. After receiving an advance degree in Biology, he left Texas and enrolled in Meharry Medical College in Nashville Tennessee. He graduated from Meharry and after further training in Ohio he settled in Atlanta, Georgia where he began the practice of Family Medicine. *Could Ernest be the doctor Mama dreamed about or could this be Satan's trick? Could it really be what the Lord was trying to convey to my mother to tell me?*

When I returned to my mama's house it was full of people. I was about to burst desiring them to hurry and leave so I could tell Mama what I had experienced around the corner. I never did find my sister's best friend, Abrha Letha. I was anxiously waiting for everybody to leave so that I could have time with Mama. Immediately after everybody left, I told her.

"Mama, you will never believe what happened when I was out. I went to see Nobleton and guess what he told me?" I shared my story about Ernest.

Mama sat there and as she looked at me she said, "You know I am telling you, I always pray and I *know* God showed it to me. You see the Lord would not let anybody else go to that house but you. You had no way of knowing what had happened. That was God's will for you to go there and get that information. He did not let anybody else go. I am telling you what I saw."

We completed plans for my sister's funeral. She died on September 19, 2002 and the funeral was on September 24, 2002. In the back of mind, I was wondering what in the world was about to happen, what was going on. I wanted to give Ernest a call, but did not want to seem presumptuous. I did call back to Nobleton's house and his wife, Lee Esther, gave me Ernest's number. I finally decided after Helen's funeral was over, I would give him a call. I did not know exactly what I was going to say. I was very uncertain about how he would receive a call from me because it had been so long since we had talked. It had been twelve years since I last saw him at his parents' Golden Wedding anniversary. I was so nervous about making that call. One night I was battling with myself. First, I thought, *I am not calling him,* and then something would urge me on—*go on and call him.* I must have fought that fight for at least fifteen minutes before I did finally call.

A man answered and I said, "May I speak to Ernest?"

The voice said, "This is Ernest."

I said, "This is someone you have probably forgotten but **I am the girl next door.**"

He said, "Which one?"

And then I stuttered, "Uh, oh, which girl am I?" I was wondering who else lived over there. It dawned on me he had to have been talking about my younger sister, Linda. I finally said, "I am the oldest one."

He said, "**Birdie?**"

We laughed and I said, "Yeah."

We began to talk and I shared with him the news of Helen's passing and he shared with me and told me about his wife, Barbara, relating everything that had happened to him since her death. We spoke on an emotional level with one another about our losses. We talked about the goodness of God and things that God would do for us and what could be done. I even told him that I had been in Tennessee. I did not know that he lived in Tennessee. I had been in Memphis in 1994 and I told Ernest how much I liked it and how I had returned to Tennessee in 2000 to a church meeting in Franklin, Tennessee. I had hoped I would have a chance to come back again. He extended an invitation that if ever I came back that way I was welcomed to come and visit—he would love for me to come. He said he was lonely.

He said, "I am in this great big old house all

by myself and I would love for you to come and visit any time. You are perfectly welcomed."

We talked a little bit longer. We must have talked for at least an hour and a half if not almost two hours. We just had a good time sharing. We finally ended our conversation, and as I hung up the phone, I thought to myself, *Wow that was one of the best conversations I have had with a man since, I do not know when.* Ernest's voice had a lovely tonal quality which increased my interest. I wondered if he might enjoy talking again.

Several days passed. I continued in my normal daily routine. I was still curious about the dream Mama shared. I really wanted to know if Ernest could be the doctor she had dreamed about. One evening I called a very close friend, Pastor Charlene Moore. I shared in detail what had occurred. She reminded me of a Women's Day Conference scheduled for October, 2002 in Franklin Tennessee. In October 2001, we had spent a week there in revival. I told her I would love to go. I thought a trip might do me good after my sister's passing. It would also allow me an opportunity to possibly see Ernest and talk again with him. I needed a vacation. Pastor Moore agreed.

I was very excited realizing that I was going to Tennessee. I began to call the airlines and try to make reservations. I called AAA trying to find hotels and places where I could stay. I knew I was to be in Franklin, Tennessee and Ernest lived in Carthage, Tennessee. I wanted to get somewhere in between both places where I could easily attend church ser-

vices and spend time visiting with Ernest when possible. I found a place in Lebanon, Tennessee and I made reservations. I decided to call Ernest to let him know. It was really funny. I said, "Ernest, I just had to call you back and guess what? I am coming to Tennessee".

He said, "Really?"

I said, "Yeah. My girlfriend is going to minister there on October 25, 2002 and I am going to come as her armor bearer and I will be in town and hopefully we can get together."

He said, "Well, no problem. Let me know the day and time of your flight and I will pick you up from the airport." He also said he would like to attend the services.

I said, "Okay," and hung up the phone. I wanted to shout, "Yes!" I felt like a little girl. I was really excited and anxious—after no contact for twelve to thirteen years. I was so anxious to talk again with Ernest.

There was something forcing me to move forward. Plans began and things started to happen. I could barely contain my excitement. When you know that God has said something and you truly believe, one has to learn how to get into the stream of His blessings. Some things might come to your door but then sometimes we have to be willing to move into the stream of God's blessings. I just felt within myself there was a possibility that there was a blessing waiting for me and it was not in Houston. It was in Tennessee. I needed to know if what Mama

dreamed was really true. If there was going to be a special relationship between us, I would know right away. I made all kinds of plans to prepare myself for the trip and finally the time arrived.

I was like a girl waiting for a blind date. I was jittery and nervous. Ernest was to meet me at the airport. I did not know what he looked like nor did he know what I looked like. He had told me the make and model of the car he would be driving. I do not know the difference between one car or another, but he told me the color which helped me. I told him what I would be wearing. I had a cute little tweed suit and would be wearing my heels. I had my hair styled and my nails perfectly painted. Finally a car pulled up to the curb. I was pushing my luggage before me on the airport buggy. He peered out the window of his car and he looked at me as if to say, "Is that her?" I was looking at him thinking, "Is that him?"

He did not look at all like the boy next door. He had a white beard which was very distinguished looking, reminding me of actor, Sean Connery. He got out of his car, gave me a hug and said hello. He placed my luggage inside the trunk of the car and we headed to my hotel room in Lebanon, Tennessee. After securing my room, we headed for Carthage, Tennessee stopping for barbecue along the way. Carthage is only 25 miles away from Lebanon. After getting food, we headed for his house. We talked, laughed and just had a good time. He showed me pictures of his daughter, granddaughter and son-in-law. We had a good time laughing with one another.

I could not keep my eyes off of him. It was really funny how each time if I bumped him a little bit he would jump. If he bumped me I would jump. We were almost running from each other. The more I think about it you know we were both kind of curious about each other.

After completing a tour of his home, we made our way to the sunroom where we continued sharing. I had brought some CD's and he also had lots of music. We listened to music as we talked and shared about life. That was the night of a beginning for us. There was something special about that time. We talked about what we both wanted. I already knew from previous conversations with him that he was not getting married again. He had told me he did not see that happening. He was going to remain as he was. He felt he was too old. He would jokingly say he was too old to train another wife. I knew that and I understood. Ernest was a self-made man. He had his own thing going. His job was in place. He had friends in this town who liked him. He had things going real well for himself. I did not expect anything more than friendship to come from the relationship. I realized he was still missing his wife, Barbara. There was something about that first night, however. As we talked, we found ourselves seated next to one another talking easily and warmly. I could feel his loneliness and need for someone in his life. He shared that the hardest part of being there was coming home each day to an empty house.

*BUT WHEN HE, THE SPIRIT OF TRUTH, COMES, HE WILL
GUIDE YOU INTO ALL TRUTH. HE WILL NOT SPEAK ON
HIS OWN; HE WILL SPEAK ONLY WHAT HE HEARS, AND
HE WILL TELL YOU WHAT IS YET TO COME. HE WILL
BRING GLORY TO ME BY TAKING FROM WHAT IS MINE
AND MAKING IT KNOWN TO YOU (JOHN 16:13–14)*

I enjoyed the weekend, and before I left,
Ernest was preparing to attend a medical conference
in Gatlinburg, Tennessee for a week. On Sunday after
church services in Franklin, I told him, "While you
are up there God is going to share something with
you."

He said "What"?

"God is going to share something with you.
He is going to tell you something."

He said, "If there is something you need to
tell me, you need to open up and you need to tell me
and tell me now." I was hesitant to say more, then,
with great force, he added, "Wait a minute, sister.
You need to tell me now. I do not want a surprise. I
need to know if there is something I need to prepare
for. I need to know now."

*IF YOU REMAIN IN ME AND MY WORDS REMAIN
IN YOU, ASK WHATEVER YOU WISH AND IT
WILL BE GIVEN YOU (JOHN 15:7).*

I thought, *Oh boy.* I was scared, but I began
to share with him about the dream. I told him what
my mother saw in her dream. He wanted to know the
location of the house in the dream.

I said, "I do not know. All I remember is that

Mama said she was getting ready to go back to the States and she woke up."

Ernest said, "Oh." Then he turned around and started talking about something else as though what I said did not mean anything. On Monday morning he drove me to the airport and that same Monday afternoon he headed to the medical conference in Gatlinburg.

Strange enough the relationship started to move. Ernest started calling me. He called me every-day, sometimes two or three times a day. I received a card in the mail every day for a whole week and each card would say more endearing, thoughtful things. The cards came so regularly that I began checking the mail looking for the little cards like a girl looks for candy or a special gift. He really had my head spinning. I thought, *Wow, you know he really knows how to get a girl's attention.* I think it was happening fast, faster than I realized. During the first week it was hard to tell one day from the other because things were moving so fast. We talked practically all night and all day. It was really some type of new rela-tionship. I felt like a feather floating on air, high and lifted up.

I knew that on the Friday of the conference he would be leaving Gatlinburg and heading to Atlanta, Georgia. He would be going to see his daughter, Zanetta. But what I did not know is that when he arrived in Atlanta he would talk with his daughter and he would let her know that he was going to start communicating with me regularly. He shared with her

because he did not want anyone else to tell her what he was doing. He wanted her to hear from his own lips first. This was fine with me because while I was visiting that weekend I had a chance to talk to her by phone. She seemed very nice and she knew that I was someone he knew from long ago. After talking with her and letting her know what he was going to do, he happily returned home with her blessings.

GIVE THANKS IN ALL CIRCUMSTANCES, FOR THIS IS GOD'S WILL FOR YOU IN CHRIST JESUS (1 THESSALONIANS 5:18)

After returning to Houston from Carthage, and finding out that Ernest had talked to Zanetta, I was very excited to say the least. I thought that I needed to talk with my Bishop, Shelton Bady, at Harvest Time Church. Bishop Bady would always encourage me. He was really the one person whom I felt would say something that was for my good and that he was a 100% friend and a pastor to me as well. I did express to him that Ernest was going to be preaching at a local church, Rome Baptist Church. Ernest had asked if I would like to come and hear him and support him on that particular Sunday. I agreed that I would like to come and in telling Bishop Bady about what had occurred and Mama's dream and everything, Bishop Bady said, "You need to go. This is of God and you need to go. It would be wonderful for you to go."

So I felt very good about making plans to return to Carthage. Well, of course, like most women, I had to look for something new to wear and I just did not see that I had anything in the closet that really

appealed to me that I thought would be very nice for a person who is visiting a church with a man of God who is going to break the Word. I wanted to look very nice. I went to a girlfriend's shop and I bought a beautiful purple suit with a very tasteful diamond-shaped pin attached to the jacket. I figured purple and silver would be nice. I had my hair styled, fingernails designed, pedicure, the whole bit. Everything had to be just right. I was very excited.

Finally the day arrived. I returned to Nashville and traveled to Lebanon where I stayed. On the day of the church service, Ernest picked me up and we drove to Rome Baptist Church. He introduced me as a friend and a visiting evangelist. One thing the Lord did was create in Ernest the ability to accept me along with the calling I had received to serve the Lord. He was strong enough to stand firm and let people know that I was an evangelist and he had invited me to come for that day. Everyone in that church was just beautiful. They were wonderful to me. I really enjoyed the fellowship. Later that afternoon, we went out to dinner with some of the members from the church, Robert and Diane Slack. We had a great time after which I had to come back home. I caught a night flight and returned to Houston.

TASTE AND SEE THAT THE LORD IS GOOD; BLESSED IS THE MAN WHO TAKES REFUGE IN HIM (PSALMS 34:8).

Chapter Five

I cried as the plane lifted from the ground. I did not want to leave. The following morning I went next door to take breakfast to my grandfather, Frank Brown. I told him I had been in Tennessee and had such a wonderful time.

He leaned back in his chair and looked at me and said, "You been to Tennessee?"

I said, "Yes, and I had such a great time. Oh, I hated to come back." He looked at me and said, "Well, Why did you"? And I said, "I had to come back and take care of you. I had to make sure you were taken care of."

He said, "Well, I can take care of myself."

He was 95 years old and was *not* able to take care of himself. He did need special attention. He had reached the point where he was really unable to live alone but was trying so hard not to be placed in a home. I knew he needed me to care for him.

I was feeling that some things were happening without human orchestration. It seemed like every-

thing was going so fast I could not keep up. Later in that week I called my nephew, Wilbert Verden in New Orleans. We often prayed together over the phone. I always enjoyed prayer and communicating with him on many family issues. I was in a place where I needed to hear from God. I needed to talk with someone I trusted and that loved me enough to help me understand what was going on.

After Wilbert and I prayed, he told me, "Auntie, I am telling you, you are going to get married. It is going to happen faster that you know."

I was somewhat incredulous.

He said, "I am telling you now, it is going to happen and it is going to happen very fast."

Well, there had not really been any sound talk about marriage between Ernest and me, but I had a feeling that, yes, it was going to happen. I was preparing myself for the possibility that this was going to take place.

As we continued talking during the month, Ernest and I talked a great deal about church. He had somewhat mentioned to me that maybe we could do a ministry together. I was trying to be open to that and whatever the possibilities might be. He had a lot on his mind. He was making a lot of life adjustments and of course God was in the midst. God is still in the midst of everything that goes on in our lives. He was trying to seek direction and really be obedient to God because he truly knew God had not left him out of what was occurring at the time. He had feelings from his first marriage and he understood that he had

feelings for me also. A lot of things that God was telling him he had not expressed totally to me, but I knew that he was moving by the power and anointing of God.

Ernest had told me he was going to come home to Houston for Thanksgiving. He did not want his parents to know he was coming. He was going to surprise them. So I kept the secret. I made sure nobody in his family knew he was going to surprise them. This was something he had planned prior to us ever coming in contact with one another. He had made this plan because he wanted to be around his family for the holidays. It was *time* for him to be around them. I did not know about some of the other plans he had. While he was planning to come I had time to prepare my house and to get some things in order. I had stopped upgrading the house I lived in because I was making plans to build a new house. You know it was just ironic how I had so many plans of building a big house on the lot I had purchased across the street from where I lived. Each time I completed an application with the contractors and was ready to build, nothing would happen. Preparing for the new house, I had purchased a huge king-sized sleigh bed. I had a beautiful white sofa and a glass-topped dining room table with white chairs. I bought everything I thought I needed for the new house. In preparing for Ernest's visit, I had the house painted. I took great interest in trying to get everything straight. I wanted everything to be perfect. I wanted an orderly and pleasant environment when

Ernest came. It was not so hard because there was not really that much to do. I did call on my sister, Linda, because she is good at decorating. There were some things that I had not coordinated very well. I even talked about colors and schemes with the girls at work. I had some great ideas although I was a little giddy, because I had not felt like this in a very long time. It was just wonderful having a relationship. It was new and very exciting to me.

I prepared myself and had everything in order. In November, two days before Thanksgiving, Ernest arrived. His brother, Eddie, brought him out to my house for a visit. I had prepared dinner, and as usual, we spent a great deal of time sharing. On his second day in town, he went to visit his parents. During his visit he told them that he was seeing somebody. He told them it was someone they knew.

His dad said, "Well, I do not know anybody in Tennessee."

His mom did not say anything.

Ernest said, "I did not say it was someone from Tennessee. I said it is someone that you know."

Right away his dad said, "Who is it."

Ernest answered and said "It is Birdie".

His mother then added, "I was about to call her name."

And Ernest said, "Yeah." He expressed to them that we were talking and he and I were seeing each other and that he wanted them to know.

His father gave his blessings and said, "It does not matter to me whom you marry. You are

grown and you can see whomever you like. But, it is nice for you to let us know."

Ernest's youngest brother, Eddie, who he talked with all the time knew we had been talking and sharing so this was no surprise to him.

MANY ARE THE PLANS IN A MAN'S HEART, BUT IT IS THE LORD'S PURPOSE THAT PREVAILS (PROVERBS 19:21)

On Thanksgiving Day we spent half a day with my mother and family and later in the afternoon we met the Jones family at Eddie and Stephanie's home. We had a great time as Nobleton and Eddie retold stories from our childhood. It was during this time that Nobleton talked about me. He said one day when his mother and my mother were hanging clothes on the line he overheard them talking. They were discussing their children and their futures; dreaming like most parents do. Nobleton went on to say that Mama asked Mrs. Jones. "Well, what do you think about Ernest and Birdie getting together and marrying one day?" Mrs. Jones told Mama "Well. I will tell you this. He is going to get a good education first and when he finishes school he will really be able to take good care of a wife." I never knew until then why Nobleton through the years said I was supposed to be his sister-in-law. Everybody continued to tell something about everybody. Being with the Jones family was very enjoyable although I had become a little tired of talking to different family members and sharing about our relationship. I guess for Ernest, things were happening in his life and he

wanted to be sure that what he was doing was right. I never told him, but I began to think perhaps I needed to fill out an application to become a Jones. Now that I have looked back at what actually happened, God had already put a seal on what was to be. During our visit, someone said that I was going to be a Jones. Stephanie, Eddie's wife, commented as she looked at me and said, "She is already a Jones." I thought this was very sweet. Of course, the feeling was that I was already a Jones because I had grown up right there in the house and kitchen with his mother. I had felt that I was a part of their family for a long time even though I was not born into their family. I was always treated so well by everyone. I did feel like a Jones. I felt quite comfortable indeed.

On Sunday after Thanksgiving Day, Ernest attended Harvest Time Church for the first time. Bishop Bady and his wife greeted Ernest with a smile.

Bishop Bady laughed as he said, "You are the person who is seeing my member?"

Ernest replied, "Well. You had better get used to the idea. You are going to be losing her soon."

Bishop Bady was smiling and laughing as he and Sister Bady both gave their blessings to us.

Later that evening Ernest returned to Carthage due to his job demand and his patients' needs. We continued to talk often by phone. It was so funny at times. I kept my cell phone on while working. I always knew or felt when he was going to call. Several staff at work would tease me often about how

different I was dressing and looking. I had such a happy, happy spirit. The Lord gave me such a glow and a feeling of being revived and renewed. I had fallen in love; absolutely and genuinely head-over-heels in love.

HE WHO FINDS A WIFE FINDS WHAT IS GOOD AND RECEIVES FAVOR FROM THE LORD (PROVERBS 18:22)

As Ernest and I continued talking there was a greater desire to enter marriage. It was beginning to feel very strong. We talked about what we might do and he felt that perhaps August of 2003 would be a good time perhaps for us to marry. Society puts a lot of pressure on people especially when one of the parties has experienced the death of their spouse. People feel you need to wait a year and give yourself time to recover and you need to be respectful for those that have been a part of your life for a long time. Truly it was our intention always to be respectful of the fact that Barbara had been a great part of his life and after 35 years he had great love for her. He still had great feelings though she had passed on. He wanted more than anything to not tarnish her memory by doing anything inappropriate in our relationship. I agreed that August would be alright. His concern was not only about respecting Barbara, but he did not want people to have a wrong opinion of me. They might think I was just out to catch him; that I did all sorts of things that were ungodly to get his attention. He did not want anyone to say anything negative concerning me. We dealt with what would be appropriate consid-

ering all concerned. My mom always said that "man make plans and God smiles."

WHO WILL BRING ANY CHARGE AGAINST WHOM GOD HAS CHOSEN? IT IS GOD WHO JUSTIFIES. WHO IS HE THAT CONDEMNS? CHRIST JESUS, WHO DIED—MORE THAN THAT, WHO WAS RAISED TO LIFE—IS AT THE RIGHT HAND OF GOD AND IS ALSO INTERCEDING FOR US (ROMANS 8:33–34).

Finally December came around. I was very concerned about my grandfather and what I needed to do concerning him. I knew that I was going to marry. In the back of my mind I kept remembering what Wilbert told me about how things were going to happen and they were going to really happen fast. Although I had agreed to marriage in August 2003, I never completely felt we would endure a long engagement. One Wednesday before going to work I attended a noonday service at Good News Church. I really did not realize how much weight I was actually carrying. During that service, the Pastor, Apostle Dorothy Washington, prayed for me. I broke down with tears flowing. One of the things she said was, "God let the people where she is going receive her." I knew without a doubt I was going to be married. I did not know how much anxiety had been pent up inside of me. I was trying to figure out what to do, how to do it, and when to do it and God truly had to be my lead. I was moving at such a rate that I could not quite keep up with what was going on. Well, later in the day, I went to work. Something had happened that caused a spontaneous response when I was talking to Ernest. He realized that I was not very happy.

He told me, "You need to give notice on that job. You are leaving and you need to let them know." He was very firm when he made the statement. He added, "You let them know that your last day will be December 24ᵗʰ."

I did not know what to say. He sounded almost like Papa again. It was really sharp. I said, "Ernest, I cannot tell these people I am leaving. I have eleven classrooms here with children and teachers and I cannot just jump like this and tell them I am leaving. You are going to have to take care of this."

"WHO ARE YOU?" HE ASKED. "I AM YOUR SERVANT RUTH" SHE SAID. "SPREAD THE CORNER OF YOUR GARMENT OVER ME, SINCE YOU ARE A KINSMAN REDEEMER (RUTH 3:9).

So he said, "Okay". I talked with him and it was decided that he was going to make a call from "Santa". On the following day I told the teachers that a special announcement was coming from Santa Claus! They sat all the children down in their classrooms. I used the intercom system to relate his message. I did not know what he was going to say or how he was going to do it but he called and I turned on the PA system. Ernest said, "Hello" and I said, "Hi."

He said, "Well this is Ernest and I have a question I want to ask you."

I said, "You have a question? Just exactly what do you want to ask me?"

He said, "Well, I want to know—will you marry me"?

And I said, "Of course, I will marry you."

You could hear the children and the teachers screaming and yelling, "You go for it Ms. Birdie! You go!"

There was a lot of happiness and teachers running down the hall. It was just a lot of fun and the little children were giggling. Everybody was really happy for me. So that is how the proposal actually occurred. Staff was then made aware of my leaving. I truly loved Teeter Totter Village but I was ready for a new life.

AND THE PEACE OF GOD, WHICH TRANSCENDS ALL UNDERSTANDING, WILL GUARD YOUR HEARTS AND MINDS IN CHRIST JESUS (PHILIPPIANS 4:7).

A few days later we selected January 03, 2003 as our wedding date. I started making plans to leave. I thought, *Well God, now they know I am going to leave and this is good.* Ernest and I began to talk about my ring and this gets very funny. I first planned to go to Carthage to select the ring that I wanted. However, I had second thoughts and decided he could choose the ring. I told him that whatever ring he chose would represent him.

During that week, Ernest purchased my ring. I flew back to Carthage to have it sized for my finger. Leaving the airport, Ernest handed me a small box. I was so nervous and excited. I was afraid to open the box. He had selected a beautiful ring. I was so excited that I called my friend, Mrs. Frazier, at Teeter Totter to tell her about my ring. I just had to share my joy with somebody. The following day I completed

the sizing for a perfect fit but was very disappointed that I could not return to Houston with my engagement ring. The jeweler would have to send it out to make the necessary adjustments.

Ernest said, "Do not worry about it. You will get it."

I said, "Gee whiz, I sure would like to have my ring." But I returned home and continued talking about the ring and how I would love to have it. During this time I had shared with Ernest about our Staff Christmas Party. I was not sure I was going to go because I did not have anybody to go with and I was really not interested in attending. Ernest had stated that he could not come for the party because he was covering another physician's patients and could not come during the Christmas Holidays. Then coming up to the party he called me and he told me that he was going to send me a package.

"You will be sending me a package? I asked.

He said, "Yes, I am going to send you the ring."

I said, "Oh no, my ring might get lost. I will just wait."

He said, "No, I am sending your ring and I am having Eddie pick it up at the airport so you can have it for the Christmas party."

I AM THE LORD, THE GOD OF ALL MANKIND. IS ANYTHING TOO HARD FOR ME? (JEREMIAH 32:27).

You see Eddie owns a courier and delivery service. Well, I got real excited with that news because

I wanted the girls to see my ring. I wanted to *show off* my ring. So I prepared to attend the Christmas Party. Eddie was to pick up the package and bring it to my house. On that particular day, before I arrived home I had trouble with my van. I broke down and I had to get AAA to tow it to my house. I was worn out; just exhausted. I knew that Eddie would arrive between five and ten o'clock that evening with my package. While waiting, a little boy who had seen the basketball goal in my yard wanted to know if I would sell it to him. I told him that it belonged to my niece and it was not for sale. Right after that Eddie arrived. Breiana and I were sitting around relaxing. Eddie walked in and said, "Birdie, you know that package I was supposed to pick up at the airport?'

I said, "Yeah."

He said, "Well, I went there and it was not there."

I said, "Oh no. Do not tell me that. That was my ring. Eddie, my ring is lost! He said it would be there and you are telling me it is not."

He said, "Yes, I went but there was no package in my name or my company's name. Have you heard form Ernest?'

I said, "Well, I tried to call him during the day and he said he was out shopping. I figured he was out buying me a Christmas present or something. I have not heard from him anymore. Let me see if I can locate him. So I immediately went to pick up the phone and I noticed behind the door where Eddie was

standing that the burglar bars moved. I said, "What is that? What is going on?"

Eddie said, "Looks like somebody is trying to come in."

I said, "Well, maybe it is the little boy coming back about the basketball goal."

All of a sudden Eddie pulled the door open and who was standing in the door but Ernest. I screamed and I hollered. It tickled them. I said, "You told me Eddie was going to pick up my package."

He said, "He did pick up your package. He picked me up from the airport."

Eddie was in on the little caper. We had so much fun with family that night. We laughed and laughed. Later we went to my mama's house. Before leaving, I had to take a breathing treatment and that really threw them. They were thinking, *this is a shame she is having an asthma attack.* I had become worked up and had been hyperventilating. I told both of them they were wrong and I was never going to forget them for playing such a trick on me. After leaving Mama's house, we went to Eddie's house where we all had more fun. It was really a big time. Ernest made a special trip in order to be with me for the Staff party. On the night of the party every one was just elated that I was with someone. They could see we were in love and, of course, I had my hand out as we danced so everyone could see my ring. It was a very good Christmas surprise.

Chapter Six

BUT RUTH REPLIED, "DON'T URGE ME TO LEAVE YOU OR TO TURN BACK FROM YOU. WHERE YOU GO I WILL GO, AND WHERE YOU STAY I WILL STAY. YOUR PEOPLE WILL BE MY PEOPLE AND YOUR GOD MY GOD (RUTH 1:16)

THAT same night I drove Ernest to the airport. He had to return to Carthage. I started making plans for my wedding. I had spent a great deal of time reading the Book of Ruth. I always prayed while reading and was very impressed by the character of Ruth and her compassion she had had for her mother-in-law, Naomi.

I knew in marrying Ernest I would be forced to move from my hometown and leave all my friends, family and all the familiar things which had been a part of my life for quite some time. I would give up so much by moving to another place, but I was willing to do so. For the first time in years I was not so concerned about others but concentrating on Birdie. I had always talked about my desire to have a Boaz in my life. I had watched my cousin Burnett and his

wife Glory Bea always holding hands and calling each other, "honey". I was impressed by Burnett's strength and love toward his wife—he was a man like the biblical Boaz. I saw Boaz not as a man of great wealth but a man that was wealthy in that he lived under the authority of God. God led him and he took care of his wife and prioritized his family. I felt now I had *my* Boaz.

I knew that I would marry in Carthage, Tennessee. A number of people could not understand why I would leave home to marry. Most brides marry in their hometown where all their family and friends are, but, God was leading me to marry in Carthage for whatever reason. The theme for my wedding was from the Book of Ruth.

I had also planned to have a large reception in Houston so that family could participate. I made lots of plans selecting a date and place for the reception and suddenly one day God told me, "This is not what I had planned for you to do." I immediately called Ernest and told him I was calling the reception off because I knew it was not the will of God. God was moving me and I was following His lead.

Whoever said a preacher could not plan a wedding—never met Rev. E. J. Jones, MD. Ernest located a professional photographer and a professional caterer for our wedding in Carthage. I made a special trip back to select the cake which would have the name Ruth written in silver on it. I almost caused a panic attack when the caterer saw that the groom's cake was to be decorated with the Kinte design. It

was topped with African Violets and the word Boaz written on the top of the bottom layer. I had wanted to exchange vows high upon a hilltop but the weather conditions were questionable. Thinking about an appropriate place which would hold a large number of individuals, I asked Ernest if we might be able to marry at Rome Baptist Church. He had preached for them several times in between pastors. Ernest had no problem in securing the church. In fact, the members were thrilled that we would want the wedding there. We also stopped by to see Mrs. Debbie Cassity of Vines and Designs about decorating the church. Ernest selected the flowers while also selecting flowers for my bridal bouquet.

Returning home, I proceeded with the plans for our wedding court. L'lana, my niece, wanted to be a maid-of-honor and Breiana, her daughter, the junior-bride's-maid. Ernest had already asked Dana, his son-in-law, if he would stand as his best man. Reverend Allen Maynard and Mr. Clifton Carter from Lily Hill Baptist Church were selected as grooms' men. Ernest's god son, Q'Lon Maynard, was the ring bearer. I needed a Matron of honor. I asked Zanetta, Ernest's daughter, if she would stand with me. Her response was, yes, without any hesitation. I also asked if Elizabeth, his granddaughter, might be our flower girl. Once again the answer was, yes. I encouraged the girls not to buy anything new; but, to find something light grey which could be worn after the wedding. Breiana and Elizabeth needed white dresses and small tiaras for their heads.

I went to David's Bridal Shop and selected a dress, but after getting home I realized it was not my wedding dress. Within my closet I found a white suit with beaded sleeves which I always looked like a bride in. It was perfect. I also had silver shoes with rhinestone straps in the closet. While shopping in the Greens Point Mall, I found a silver halo and complete matching male and female African wedding attire for our church reception.

For months I seemed to have bridal syndrome—just looking at food often caused nausea. Having everything in place, I was ready for January 03, 2003 except for one exception. My grandfather, Uncle Frank, needed special attention. I could not leave him unattended. I began visiting nursing facilities and found a place not very far from his home. It was very clean and staffed very well. On December 27, 2002 he moved into Winter Haven Convalescent Home.

Once again and for the last time I boarded a plane for Carthage Tennessee. I was so tired that I slept through the trip. Every night and often while in bed I would listen to a love song on CD by Dr. Beau Williams entitled "The Greatest Gift". In this CD he dedicates his songs to his wife. I decided that this would be my music for the bridal march. I did not want the traditional bridal march.

My wedding was really better than I thought it would be. The church was decorated with flowers of white carnations and lilies with silver bows and soft candle light. The church was filled with people

whom I did not know, but who loved and respected Ernest. I was thrilled by such a large turn out on such a cold Friday night. I realized how Ruth must have felt when she married Boaz away from her homeland. One of my best friends, Rev. Betty Phifer came from Houston to sing the "Lord's Prayer". Our wedding programs were designed by my god daughter, Lenitha Bullock in Houston, Texas. Having only basic information about the wedding she unknowingly selected a cover design displaying tulips which are my favorite flowers.

A few minutes before coming down the aisle, my niece L'lana, told me to look on the front row of the church I had a surprise waiting. Upon entering the sanctuary Gospel singer, Dr. Beau Williams' song "The Greatest Gift" was playing. Resting my palm on top of my nephew Wilbert's hand, we slowly started walking. I thought while looking at him, *I wish Helen were still living and could have been here.* But, Wilbert's presence was a symbolic statement that Helen *was* there. I could hear her saying, "Reverend Birdie, you look so pretty."

From a distance I could see my Boaz waiting. As I finally reached the steps leading to the arch, Ernest reached for my hand. Rev. Earl Dirkson began the ceremony by addressing the congregation. Recalling L'lana's words, I noticed seated on the front pew was another of my best friends from Houston, Helena Hellerton. She was smiling while she videotaped the services. I was so surprised I almost called her name out loud. Completing our vows and exchang-

ing rings, we entered our new life together with an old African tradition never seen before by most of our guests—"we jumped the broom". We stood for photographs and finally rushed up stairs where we changed into traditional African ceremonial attire for our reception. I had a wonderful time meeting my new friends.

> BOAZ REPLIED, "I'VE BEEN TOLD ALL ABOUT WHAT YOU HAVE DONE FOR YOUR MOTHER-IN-LAW SINCE THE DEATH OF YOUR HUSBAND—HOW YOU LEFT YOUR FATHER AND MOTHER AND YOUR HOMELAND AND COME TO LIVE WITH A PEOPLE YOU DID NOT KNOW BEFORE. MAY THE LORD REPAY YOU FOR WHAT YOU HAVE DONE. MAY YOU BE RICHLY REWARDED BY THE LORD THE GOD OF ISRAEL, UNDER WHOSE WINGS YOU HAVE COME TO TAKE REFUGE (RUTH 2:11-12).

Something very funny happened during the reception. As so many individuals congratulated us, Jimmy Swann, his wife Pam and his daughter Rachael asked me if "Doc" was going to remain in Carthage. I told them he was staying. Almost an hour later Jimmy came back to ask for reassurance of his staying. I said, "Yes, he is here to stay." I discovered later that Jimmy was like Ernest's brother, the whole family had adopted Ernest.

After the wedding and reception, we returned to my new home where our family and out of town friends had gathered to continue celebrating this joyous occasion. It was our plan to honeymoon in Gatlinburg, Tennessee but the weather became very bad having a great deal of snow on the road. I really

did not regret having to wait for a later honeymoon. I was happy just being in my new surroundings with family. The next day we drove high up in the mountains providing a little sight seeing for Betty, Helena, L'lana and Breiana. By Sunday morning all of our guests had returned home leaving us alone, as husband and wife. We did exactly what God would have us do and we were very happy.

Reflecting upon the past events leading to our union as husband and wife, I realize Gail Patterson's prophesy is now complete. She said someone in my family would help me with my ministry. Years passed and no one in the family showed interest in the ministry. I did not have a husband, therefore, I did not include one in my future. Two weeks after our marriage I united with the Lily Hill Baptist Church. Ernest had been the pastor of this church for five years before resigning as pastor. He still considered Lily Hill his home church. Six months later on August 10, 2003 Ernest and I started a new church. He prayed to seek God's guidance as we discussed the name for the new church. As he did I was praying that the name "God's Way Ministry" would continue. He came back to me one day and he said, "I can not hear anything but God's Way." I said, "Well, maybe God's Way Community Church is what it could be. We agreed that this is what it would be. He would pastor and I decided that I wanted to continue as the evangelist. This is what I felt would be best for us, the church, and the part that I could do well to help him build the church in this community. So together

we enjoy building the house of the Lord. We work hard as servants in helping God build His church. On October 17, 2004 I was ordained by Rev. E. J. Jones before God's Way Community Church members and the Carthage community. I now have all the rights and privileges as other ministers serving God's people.

HOW BEAUTIFUL ON THE MOUNTAINS ARE THE FEET OF THOSE WHO BRING GOOD NEWS, WHO PROCLAIM PEACE, WHO BRING GOOD TIDINGS, WHO PROCLAIM SALVATION, WHO SAY TO ZION, YOUR GOD REIGNS! (ISAIAH 52:7).

January 03, 2004, we celebrated our first anniversary. Our second anniversary was spent in Atlanta Georgia. Ernest is still a lot of fun when it comes to greeting cards. Throughout the year he leaves notes and cards around the house for me and I have developed the same practice and started leaving cards for him as well. He enjoys purchasing all kinds of things for me. He loves to buy me clothes and he has very good taste! I have enjoyed making changes in the house. I have been turning his clothes drawers upside down and changing everything possible. The house is large and it is just the two of us but we enjoy each other and we enjoy our life. Our marriage has given me the opportunity to be a grandmother. Our granddaughter, Elizabeth Danielle, like our niece, Breiana Lynnyea loves me and she now calls me "Mama Birdie". This is a name I always wanted to be called and I am very proud of them and the name they have given me. I have been told that my story is a fairytale and people listen with amazement when I

share my story—many shed tears. You can see tears in the eyes of women who desired in their hearts to have God intervene in their lives and bless them in such a way as I have been blessed.

I truly believe everything happens in its season. God planned my life in such a way that there was no error. Everything was worked out according to His perfect will. My husband is a medical doctor, and just as Mama dreamed, everything God showed her came to pass.

Our house is lovely. Everything I have has been given by God and it is just as lovely as my mother said it was in her dream. Of course, we do not have any of our relatives living here in Tennessee so our church and members of the community have become our extended family. I am enjoying the benefits God has prepared for me. It is a wonderful experience. Our total union was planned by God. It was planned by Him long ago and I am very happy with what has happened.

YOUR KINGDOM IS AN EVERLASTING KING-
DOM AND YOUR DOMINION ENDURES THROUGH
ALL GENERATIONS (PSALMS 145:3)

The Word of God is so real. As He has led me to write my story, I have come to realize that He is true to His Word. God is a God who keeps His promise. He told me to **"seek ye first the Kingdom of God and His righteousness and everything else would be added."** I can recall kneeling beside my bedside after my divorce crying out to God, unhappy

about being alone. I felt as though I had nothing or no one. I wanted the familiar things which I had lost. I wanted a husband and a family. I did not know that God was about to prepare me for something good; restore me for His purpose. Eighteen years of preparation seems like a long time but not in the eye of the Savior for, "one day is but a thousand" with the Lord.

PAY ATTENTION AND LISTEN TO THE SAYING OF THE WISE; APPLY YOUR HEART TO WHAT I TEACH (PROVERBS 22:17)

As time has passed, I have come to recognize that God has to complete the work He had started in me before answering my prayers. His "no" was not forever, but necessary for my good. I now realize that His answer was to *wait* and was not a definite "no" answer. I want women everywhere to know that God will do what He said. In his book, *Woman, Thou Art Loosed,* Bishop T. D. Jakes states "The abused little girl with all her wounds was healed by the stripes of Jesus (Isaiah 53:5). The sins of the woman who wanted to fulfill her lusts was crucified on the cross with Him (Galatians 2:22). The past is paid for. The wounds may leave scars, but the scars are only there to remind us that we are human. Everyone has scars."

In reading about my life, you can see that in all the joy, pain, disobedience and sorrow, God shows His love toward me. He provided a mate; someone whom I met forty-six years ago. After eighteen years of being single, God fulfilled His promise

with someone I had completely forgotten about. It is the person I would never have thought about. God moved in His own time and gave me someone compatible. I wanted a saved husband and a Christian home and God has granted my requests. My husband is someone who would do what God wanted in order to complete the calling God had begun in my life. God is not aimless.

TRUST IN THE LORD WITH ALL YOUR HEART AND LEAN NOT ON YOUR OWN UNDERSTANDING; IN ALL YOUR WAYS ACKNOWLEDGE HIM AND HE WILL MAKE YOUR PATH STRAIGHT (PROVERBS 3:5–6).

Closing Note

I am so grateful to God. I want you to know that God has not forgotten about you. *There is a Boaz out there just for you!*

DO NOT BE ANXIOUS ABOUT ANYTHING, BUT IN EVERY-THING, BY PRAYER AND PETITION, WITH THANKSGIVING PRESENT YOUR REQUEST TO GOD (PHILIPPIANS 4:6).

Mama said, she always prayed for God not to let anything slip upon her. Her prayers were answered. God set this divine union in place. Gospel artist, Dr. Beau Williams said in his CD " . . . that marriages are made in heaven but they must be maintained on earth." Everything that has happened this far is God's purpose. Ever so rich was Boaz but he had a need. He needed Ruth. Ernest J. Jones, MD needed a Birdie. I became his Ruth. I was willing to leave my homeland to be with him; to accept what he had to offer me. Mike Murdock says "What you are willing to walk away from determines what God can get through to you." I can truly say today that I have been blessed. My grandmother (Rosie Lee) always encouraged me with her favorite scripture:

WAIT ON THE LORD; BE OF GOOD COUR-
AGE, AND HE SHALL STRENGTHEN THINE HEART;
WAIT I SAY, ON THE LORD (PSALMS 27:14).

I encourage you to wait, for God has not forgotten you.

I pray:

THAT THE EYES OF YOUR HEART MAY BE ENLIGHTENED
IN ORDER THAT YOU MAY KNOW THE HOPE TO WHICH
GOD HAS CALLED YOU, THE RICHES OF HIS GLORIOUS
INHERITANCE IN THE SAINTS, AND HIS INCOMPARABLY
GREAT POWER FOR US WHO BELIEVE
(EPHESIANS 1:18–19).

AMEN

BIRDIE, AGE 10

BIRDIE,
AGE 13

ERNEST,
AGE 10

ERNEST,
AGE 21

MAMA-
BEATRICE
JOHNSON IKNER

DADDY-
WILLIE M.
JOHNSON

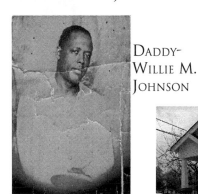

MAMA'S
RENT
HOUSE

HELEN, MAMA,
JANICE, LINDA

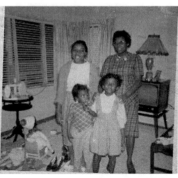

BIRDIE LEE WATTS "NINNIE"

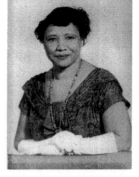

MY NEW HOME IN
CARTHAGE, TN WITH REV. ERNEST
J. JONES,
MD

DR. ERNEST JONES, MD

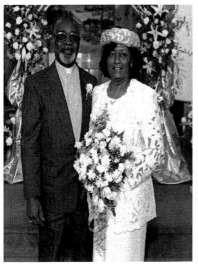

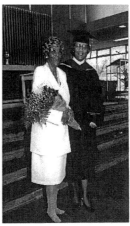

BIRDIE & MAMA
GRADUATION DAY
WEDDING DAY HOUSTON
ERNEST & BIRDIE ‾ GRADUATE SCHOOL
JAN. 3, 2003 THEOLOGY

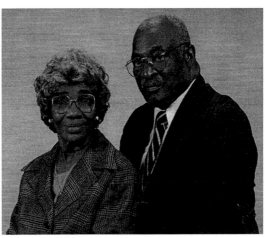

MR. ULYSSES (PAPA) & EUNICE JONES

Contact Birdie Lee Jones
kappa01@comcast.net
or order more copies of this book at

TATE PUBLISHING, LLC

127 East Trade Center Terrace
Mustang, OK 73064

(888) 361 - 9473

Tate Publishing, LLC

www.tatepublishing.com